M000087778

To Spencer —

THE ELEPHANT
IN THE ROOM

Happy birthday
and all good
things.

— Jon Berlin

THE ELEPHANT IN THE ROOM

FROM THE MIND & HAND OF

JACK BENDER

INKSHARES

SAN FRANCISCO

Copyright © 2015 by Jack Bender

All rights reserved. Written by Jack Bender.

No part of this book may be reproduced, or stored in a retrieval system, or transmitted in any form or by any means, electronic, mechanical, photocopying, recording, or otherwise, without express written permission of the publisher.

Published by Inkshares, Inc., San Francisco, California
www.inkshares.com

Designed by McFadden & Thorpe and Girl Friday Productions
Edited by Girl Friday Productions
www.girlfridayproductions.com

ISBN: 9781941758793
e-ISBN: 9781941758809
Library of Congress Control Number: 2015953763

First edition

Printed in the United States of America

DEDICATION

For my parents, Jack and Bernice Bender, who allowed me to find my life.
And for my exquisite wife, Rabbi Laura Owens, who helps me live it every day.

To my incomparable daughters, Sophie and Hannah,
may they always remember who they are.

And to Katharine Werner, my gifted assistant,
who was there every step of the way.

WHEN I WAS YOUNG,

I would ride my bike through alleys discovering the junk behind stores. Dragging home old doors, rusty pipes, and other discarded treasures, I'd hammer them together into some design, add paint, and call it art. Whether other people called it art wasn't what mattered. For me, it was the making of it—and losing myself in the process of transformation.

Years later, I am still doing that.

As a director and producer, I have been extremely fortunate to be a part of some of the best stories ever told on television, including *Alias*, *The Sopranos*, *Lost*, and, most recently, *Game of Thrones*—all great stories told by great storytellers and shared worldwide.

More than anything else, I am a visual storyteller. Whether in a theater, on canvas, or in film, my passion has always been creating stories that take people on some kind of ride—a ride to a place where something is revealed. A place of transformation.

Although I studied fine art, I think of what I create as a kind of folk art: somewhat messy and imperfect like the lives we live. When the unexpected happens—the surprise drip of paint or an actor bringing something to a scene I hadn't thought of—those are the sparks that fuel the transformation. When something like that happens, I call it a "Junk Blessing."

One morning, followed by our dogs, I was crossing the yard to my studio to paint. Not sure what I wanted to paint, I spotted a broken pool hose lying on the ground, and thinking it looked like an elephant's trunk, I took it into the studio. Before I knew it, I was hammering it onto a canvas and painting it grey. Then came the elephant around it. Then the words, "I AM THE ELEPHANT IN THE ROOM."

That was the beginning of this book: the idea that there is this big beautiful beast sitting silently in our living rooms, not judging, just witnessing the messy uncomfortable junk we don't like to talk about.

Combining my paintings, sculptures, and drawings with minimal words, *The Elephant in the Room* tells adult stories as if written with crayons.

I hope you find something of yourselves in this book, something you recognize about the human struggle to transform the junk of our lives into something better.

I wish you all "Junk Blessings" and a ride to that place.

—J.B., Belfast 2015

ANIMAL
LOGIC

I am the Elephant in the room,
the beast never mentioned,
the eggshells you walk on,
fearing the uncomfortable ooze inside.

So I just sit there,
silent and large,

Minding my own business
but far from invisible.

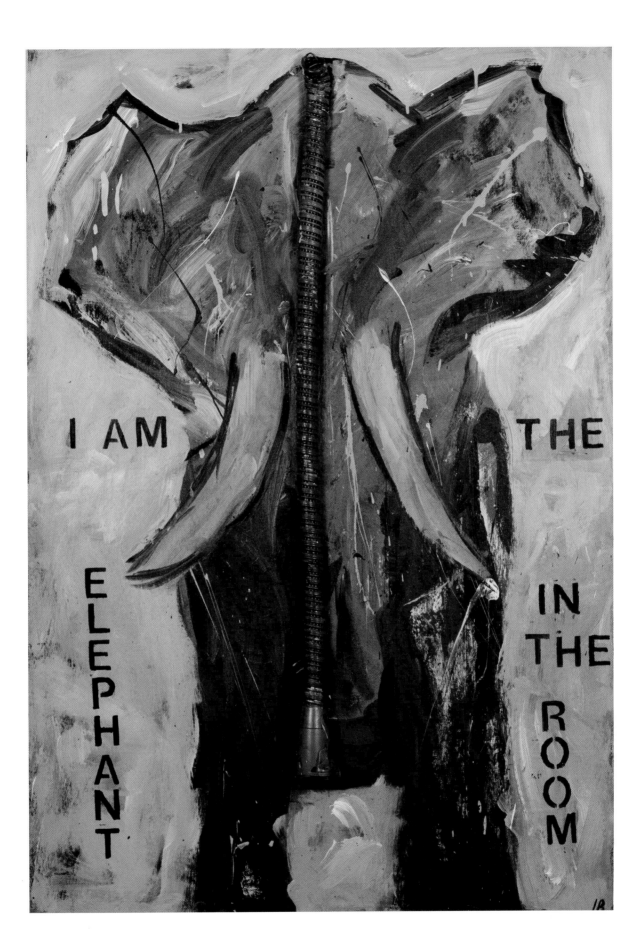

I am a Bear.

I get the same annoying question all the time.

I answer as politely as I can.

"Where else would I shit?"

I am a Horse of a different color.

I shock people,
piss them off.
They laugh when they see me
because I am not
what they're used to.

They can kiss my
cerulean blue horse's ass.

I am a Polar Bear.

I live up north in the Arctic.

If you think global warming is bullshit,
come hang out with me and my family
and watch our home melting away

**Faster than the ice cubes
in your Diet Coke.**

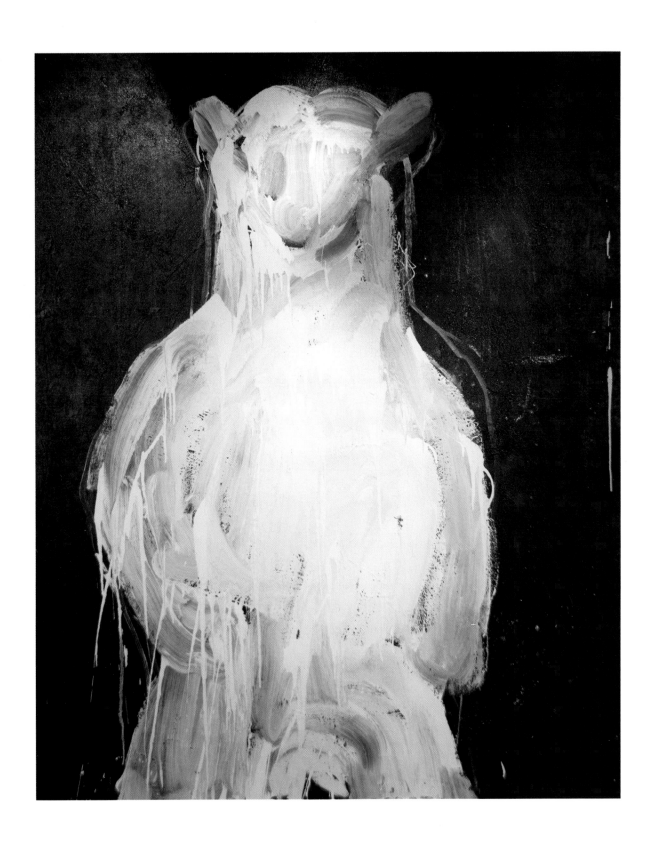

I am a Monkey.

I have seen, heard, and spoken evil.

Guess that makes me your closest relative.

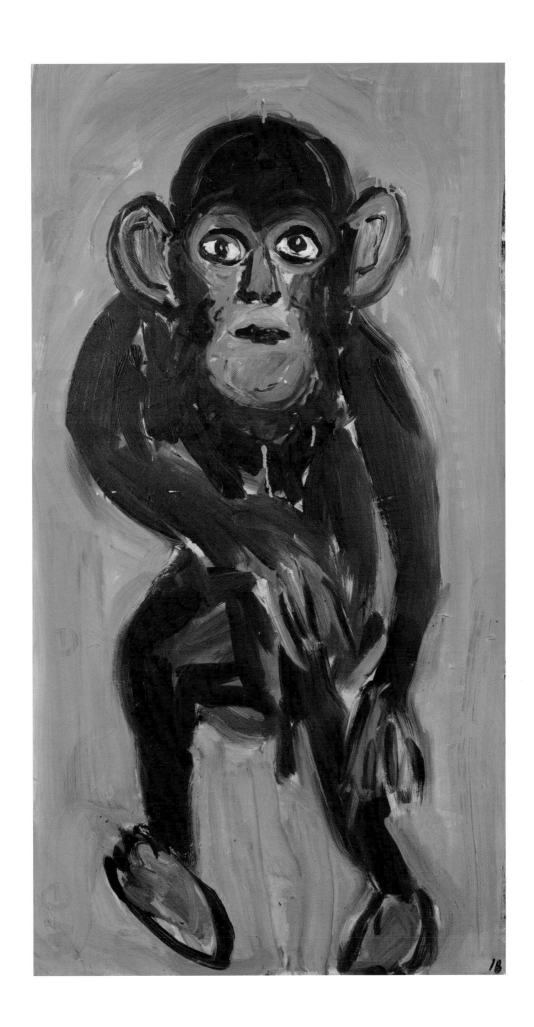

I am a Hyena.

People think I'm always laughing,
but that's just the way my face goes.

It's better than resting bitchface.

I am a Dog.

They say it's a
dog-eat-dog world,
but from where I sit

It's much more
man-eat-man.

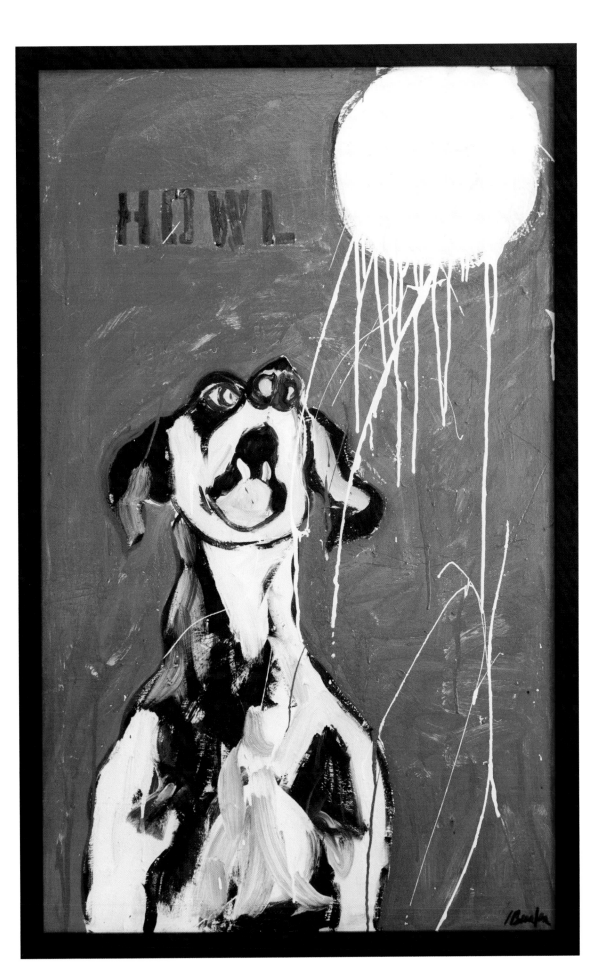

I am an Owl.

And when I hear
"Hoo cares?"
I can't help but agree.

Until the bulldozers level my forest, then I sure as hell will.

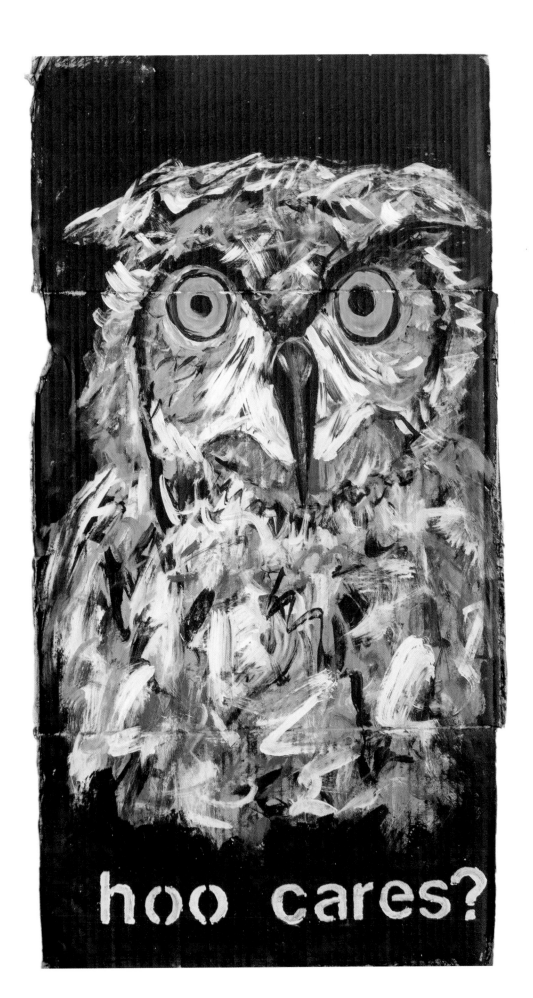

I am a Camel.

I walk around with this
big hump on my back.

So why's everyone
always staring
at my toes?

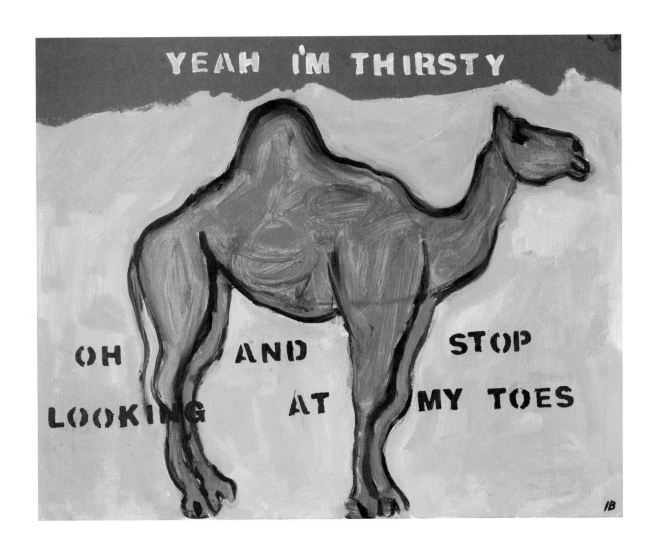

THE URBAN ACROBATS

Carla and Reuben were just a couple of street kids who defied gravity.

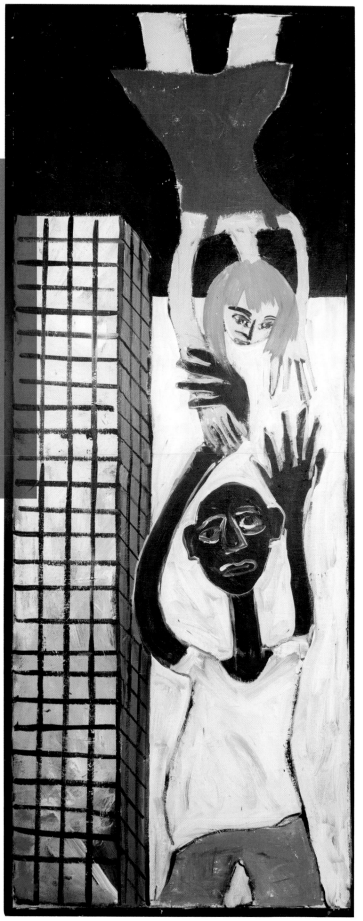

EVEN IF YOU
WERE BORN
IN A BOX

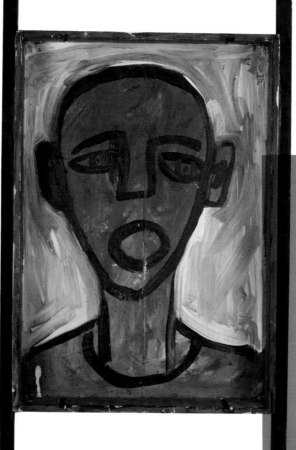

They were
brought up
in separate,
but equally
abusive,
homes.

IT DOESN'T
MEAN YOU HAVE
TO LIVE THERE

To keep their hearts from freezing over, Carla and Reuben imagined themselves floating upside down above the pain.

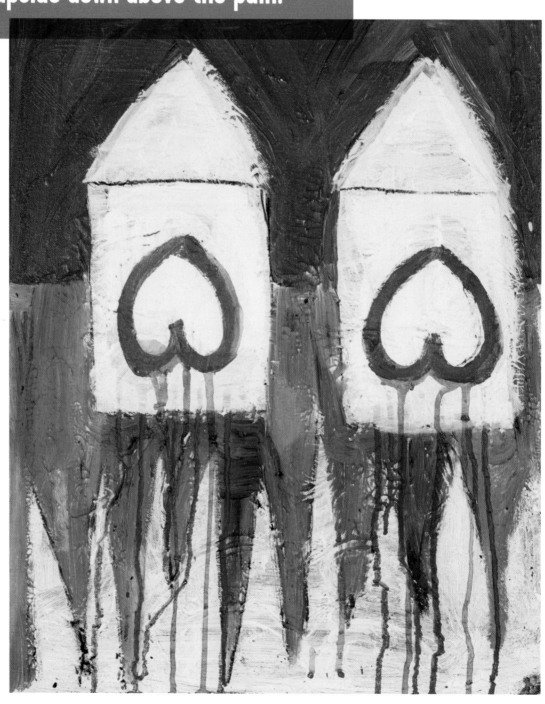

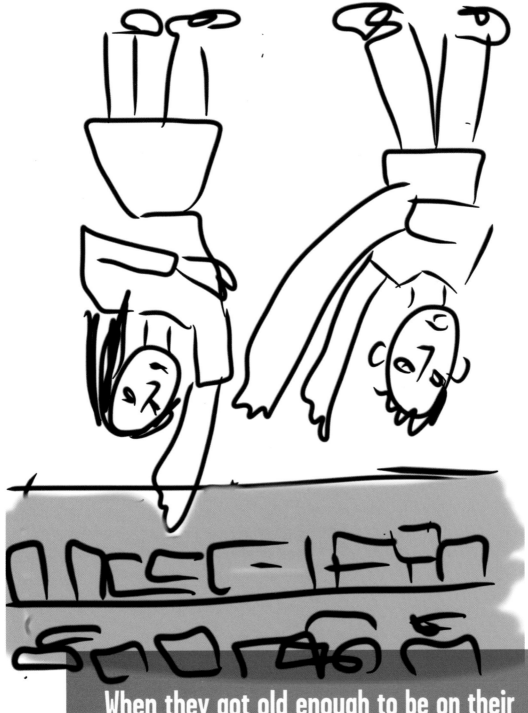

When they got old enough to be on their own, Reuben and Carla escaped to the freedom of the streets. They met working at a RadioShack, where they were both fired for stacking products upside down.

Sharing their secret, they began to float together. They lost their virginity upside down like a couple of street punk Marc Chagall lovers.

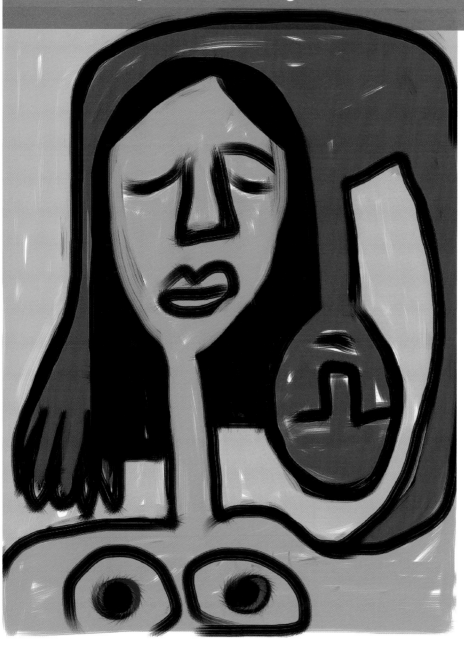

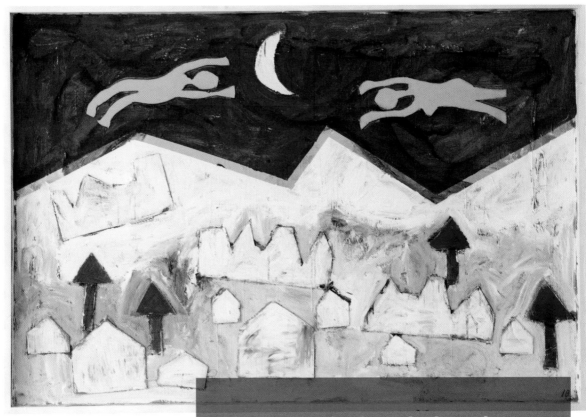

At the end of each day, they would go for evening "floats," as they called them.

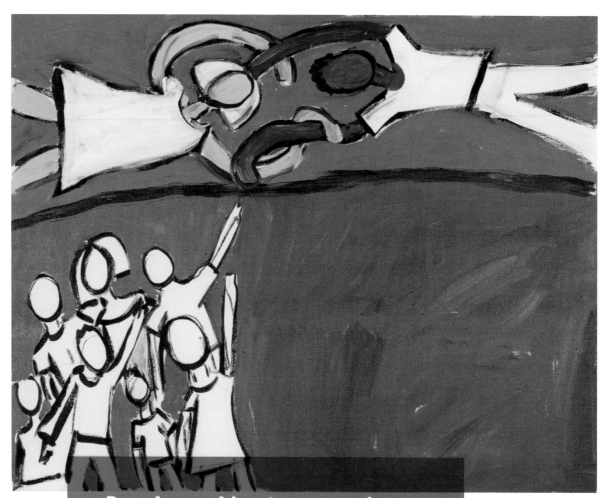

People would point up and
shout, "Hey, there go the
floaters!" Before they knew it,
Carla and Reuben were doing
their act above amazed crowds
at malls around the city.

The world-famous architect Frank Gehry built them an upside-down house with extra-high ceilings for floatability.

One rainy day, G-men came knocking on their door. As she let them inside, Carla noticed the rain was falling up instead of down.

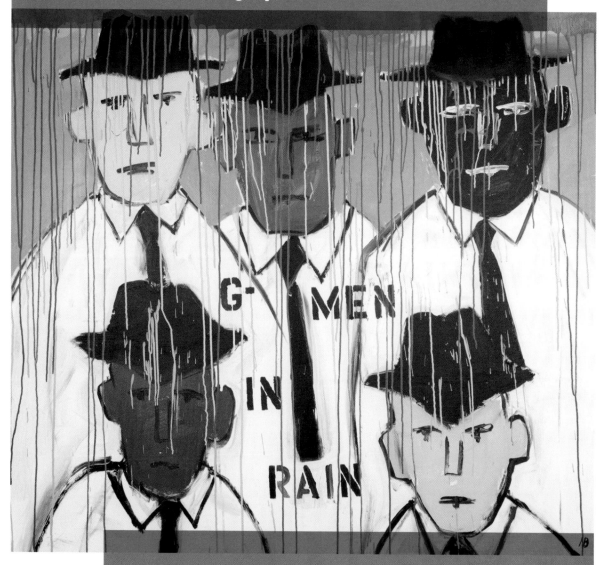

The G-men spoke in unison (as G-men always do): "Defying gravity is no laughing matter."

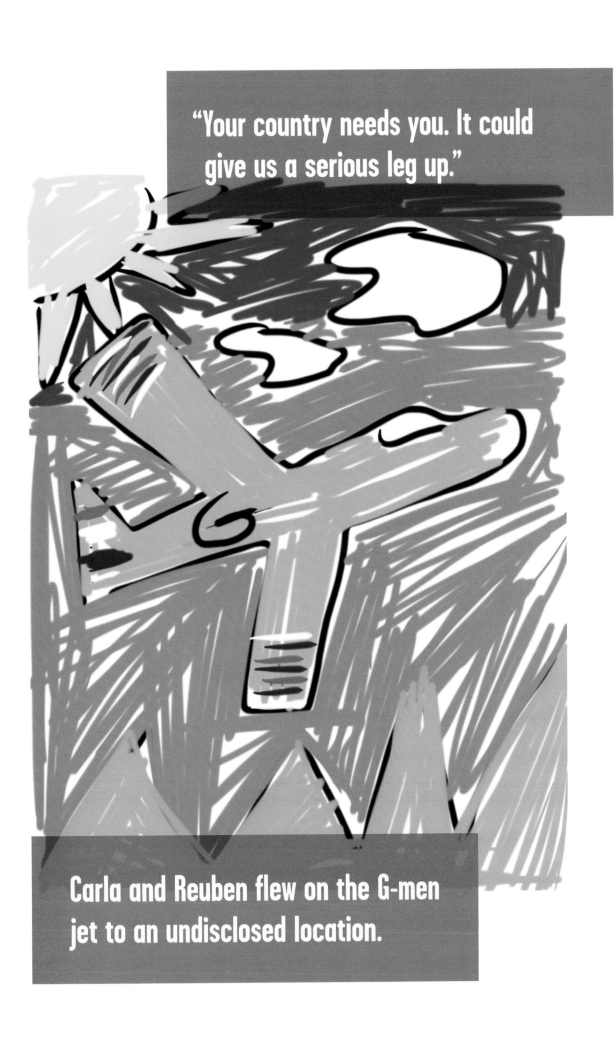

It was in a sterile white room in a top-secret underground facility somewhere in Nevada, where everything changed. After months of being poked, prodded, and psychologically tested, Carla woke up one morning unable to rise.

Reuben watched from above as his lover and best friend desperately tried to reach him. But it was no use.

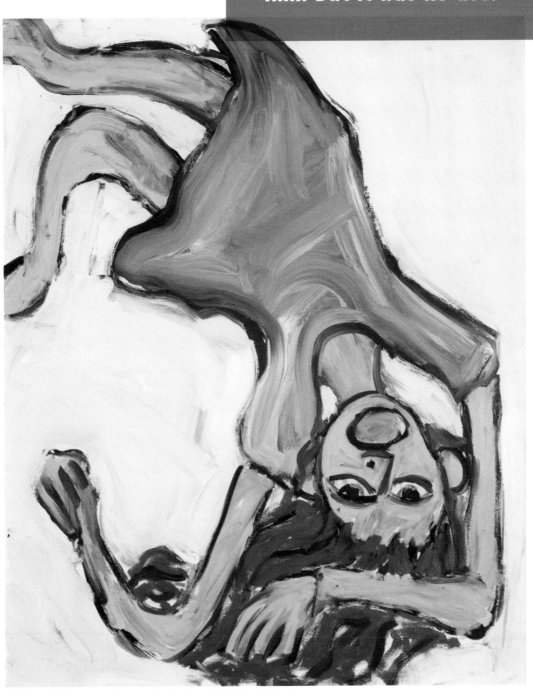

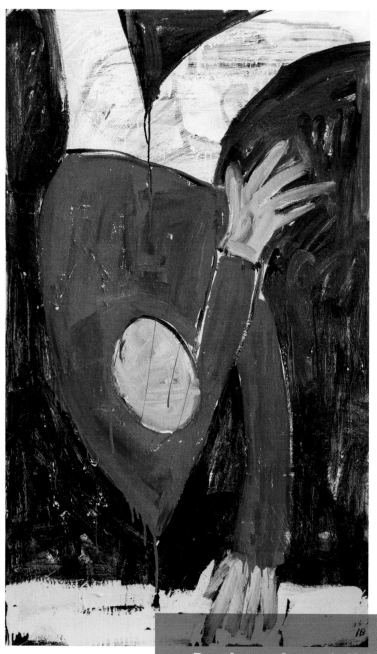

Reuben then fell like a lab-rat Icarus onto the floor beside Carla. Looking at each other, they noticed their tears were no longer falling up, but down.

The G-men thanked them for their service. Back home, Carla kept looking at herself in the mirror trying to remember who she was.

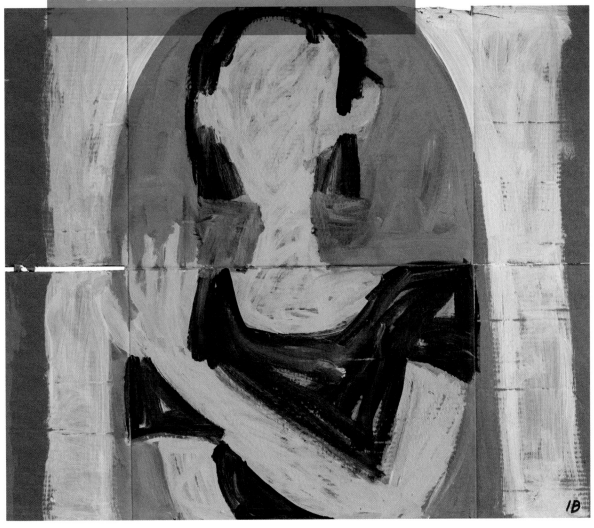

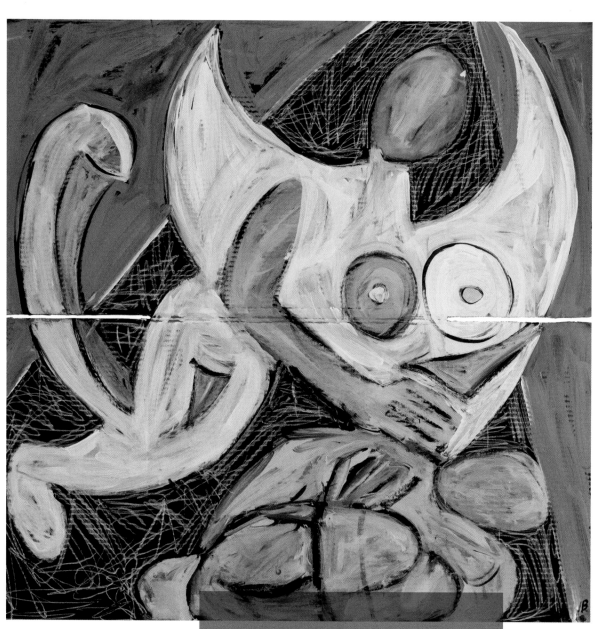

Reuben felt helpless and kept waiting for an angel to lift him up.

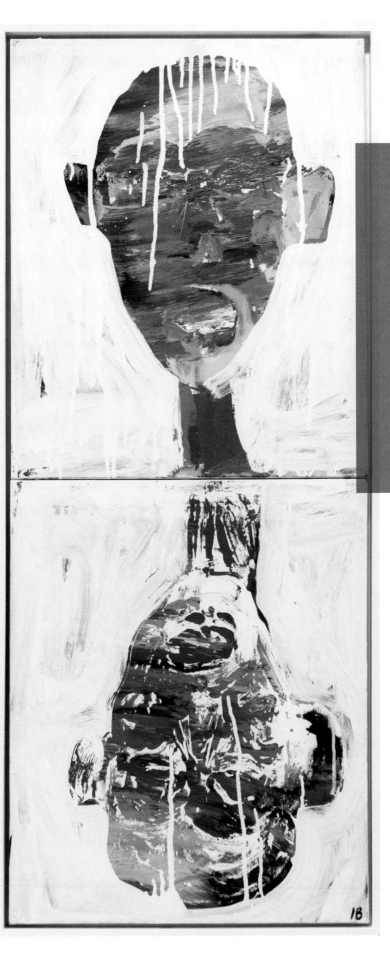

Depressed, he started to drink and do drugs, trying to get back that floating feeling.

18

Carla moved out and
lived back on the streets,
prostituting for cash.

Whenever people recognized them they shouted angry slurs. "Why do they hate us so much?" Reuben asked Seymour, the old man who sat next to him at the Russian steam baths. "We never promised anything to anybody."

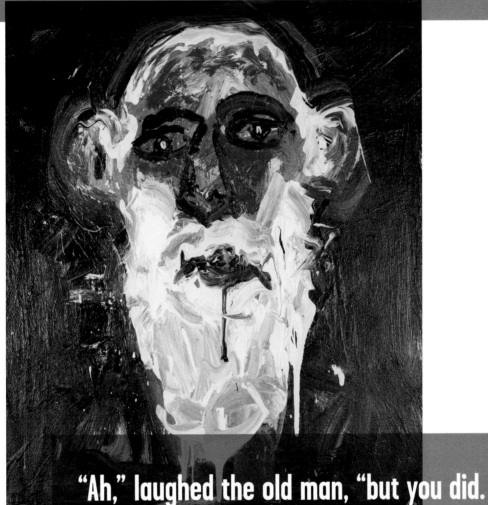

"Ah," laughed the old man, "but you did. You promised a world where you define your own rules. But, eventually, the world decides what is up and what is down."

A year later, Reuben and Carla passed each other on the street. Reuben was the first to reach out. Carla was embarrassed by the life she had been living and was shy at first.

Over coffee, it didn't take long before they were talking like they used to. Sharing disappointments and whatever dreams were left in them, they decided to move back in together.

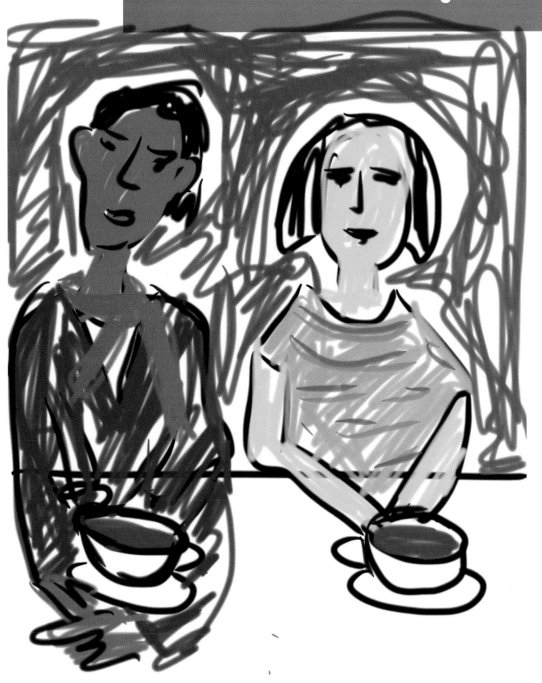

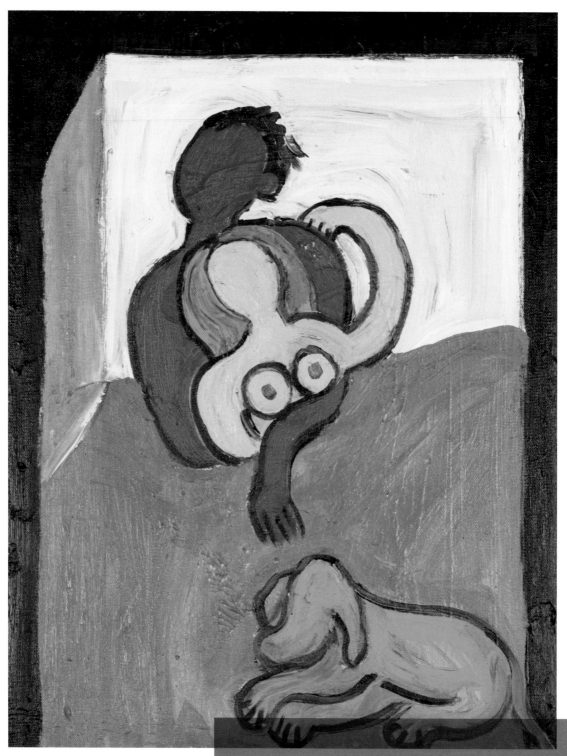

They even learned to make love in a bed like other people and actually liked it.

Carla went back to school and became a psychologist who found that abused dogs and kids could learn from each other and heal.

Reuben became a painter.
Major collectors and
museums vied for his work.

Although Reuben now lived right side up, his paintings were upside down.

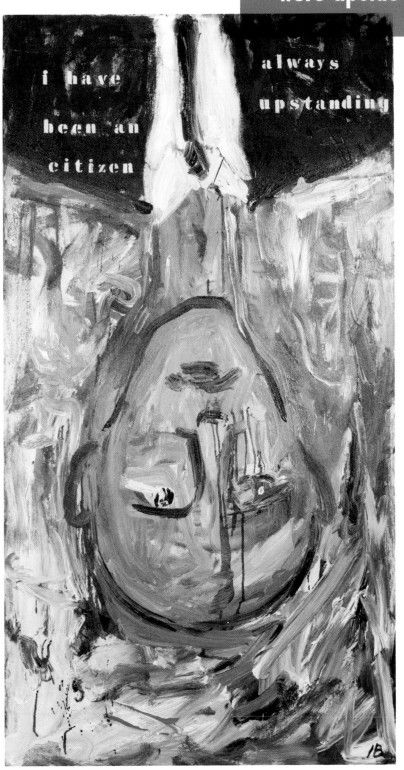

i have been an citizen

always upstanding

WANDA
WOKE UP

Wanda fell asleep and

had a dream . . .

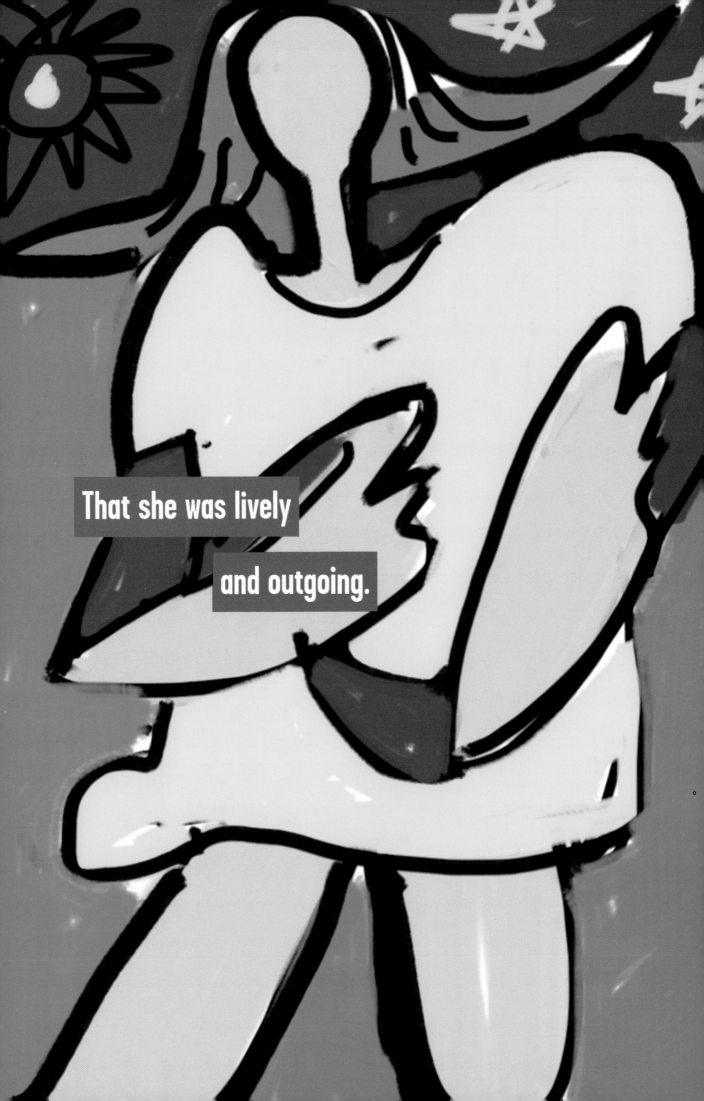

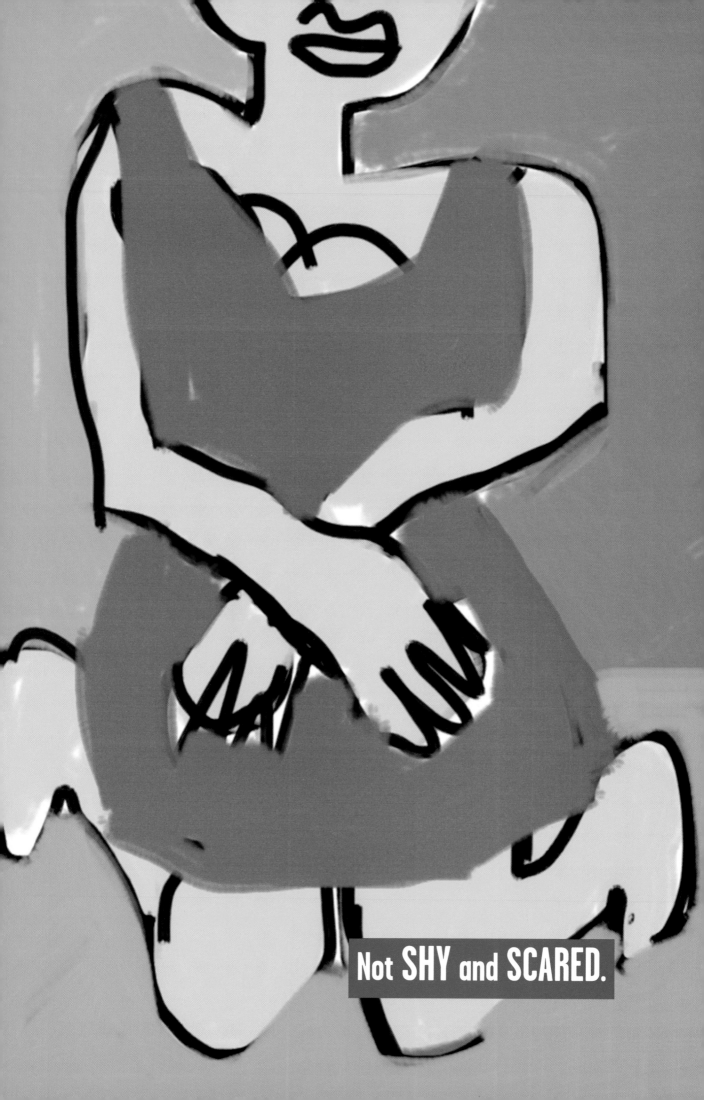

Not SHY and SCARED.

She normally stayed home

and drank wine by herself.

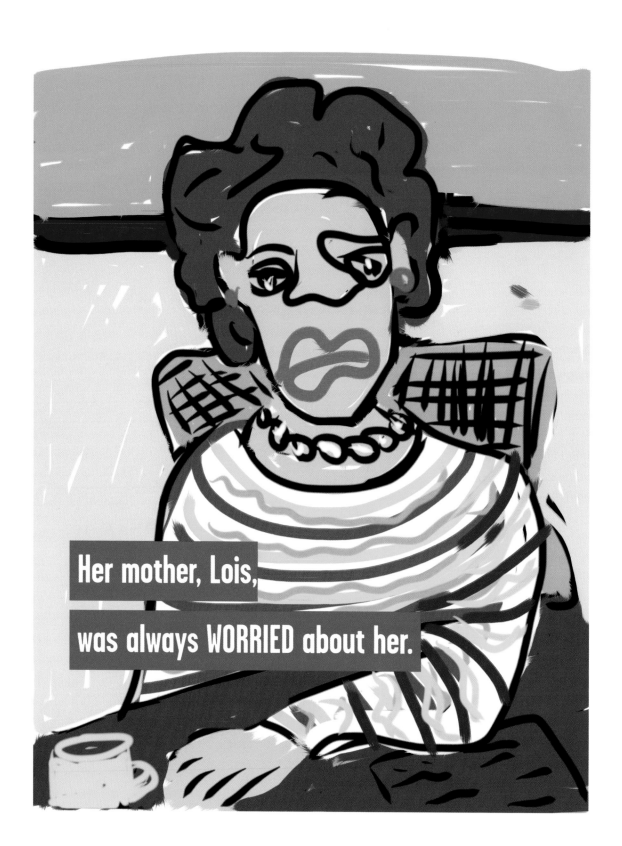

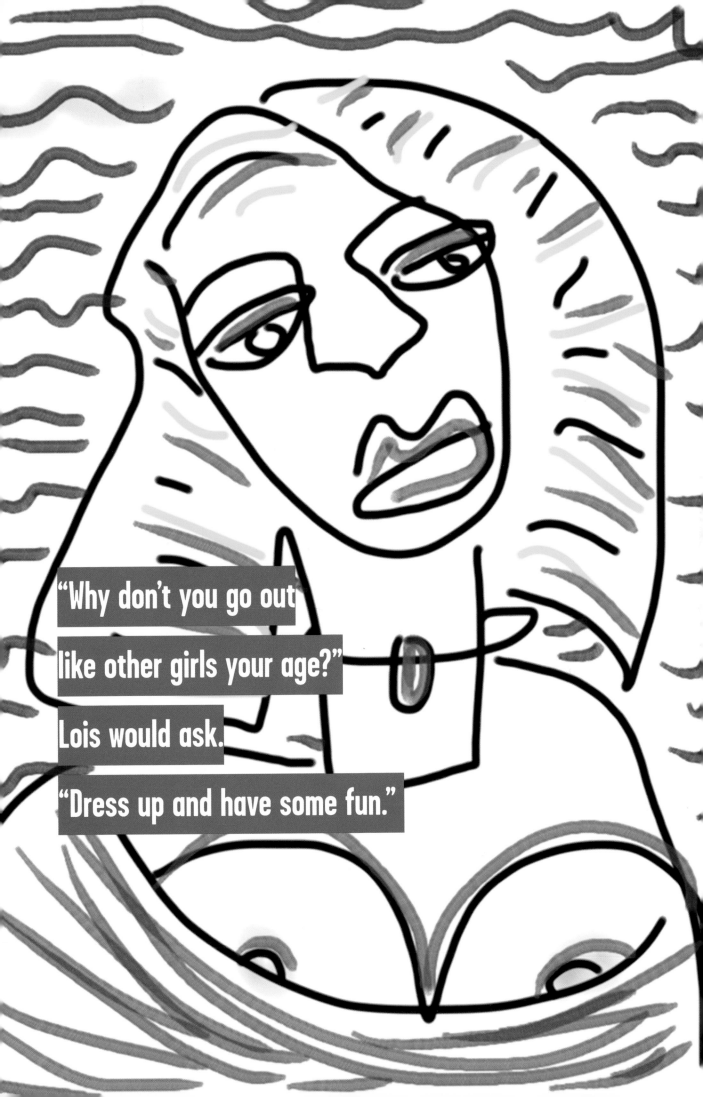

"BECAUSE I AM TERRIFIED!"

she heard herself yell back, but didn't.

Finally, Wanda went to a therapist.

Who LISTENED

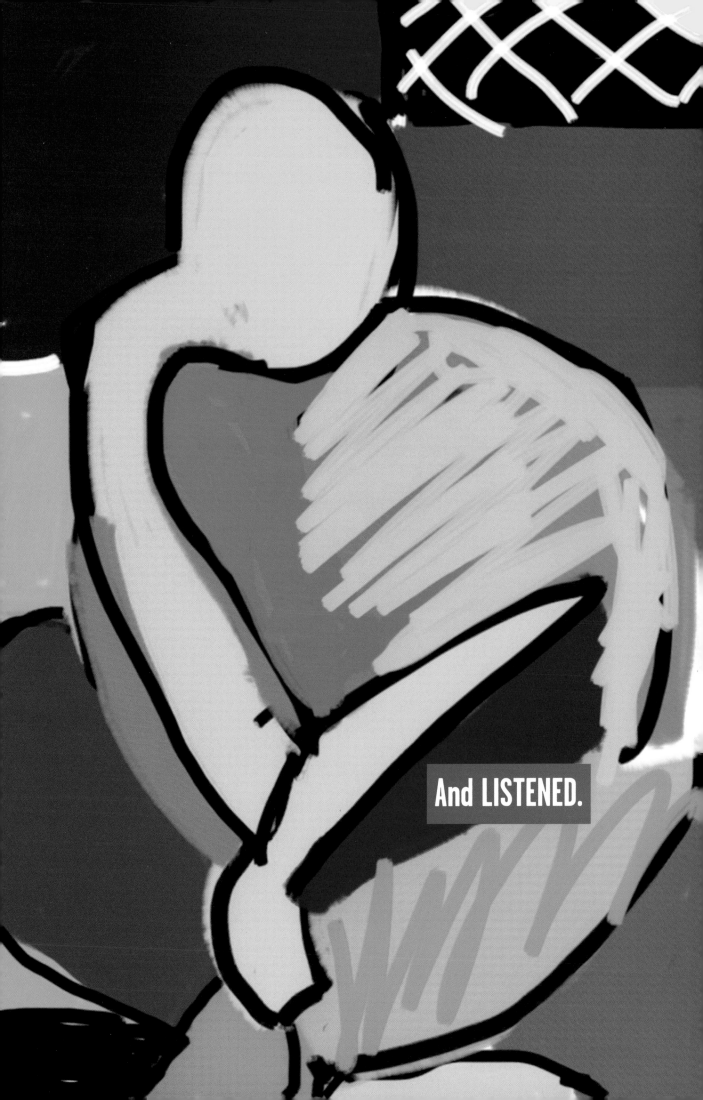

And LISTENED.

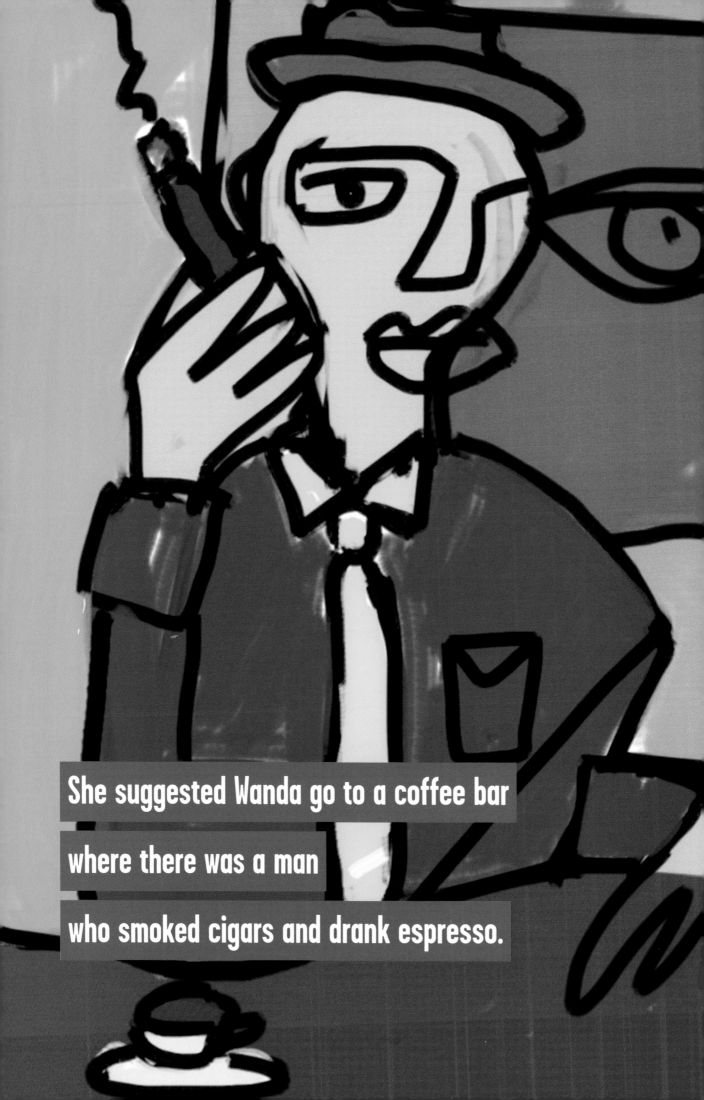

She suggested Wanda go to a coffee bar where there was a man who smoked cigars and drank espresso.

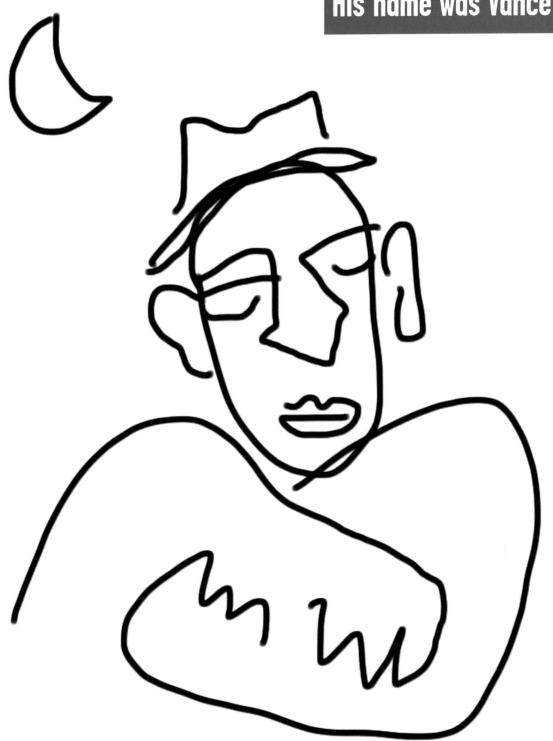

His name was Vance

and he fell asleep and had a dream.

Wanda was in it! She was naked, but so EXCITED to be in someone else's dream. Especially a man's!

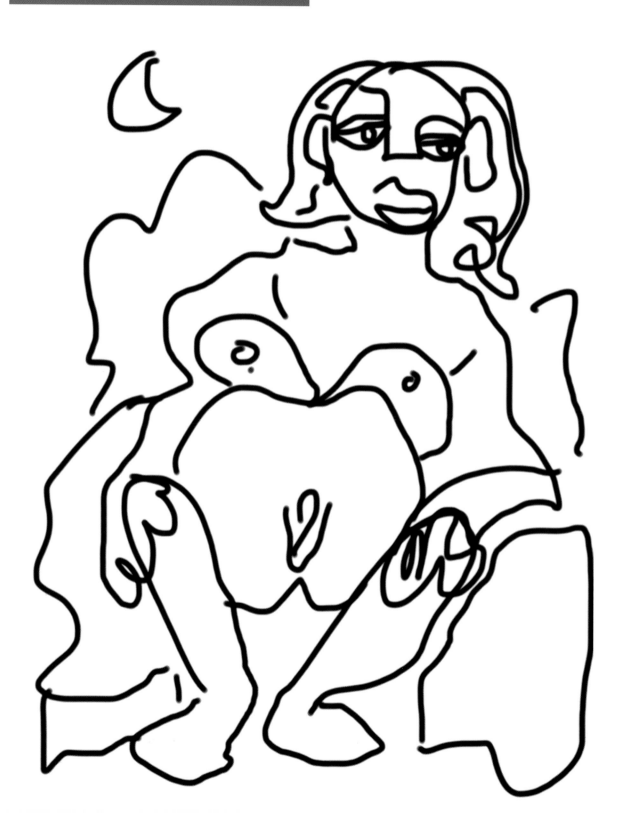

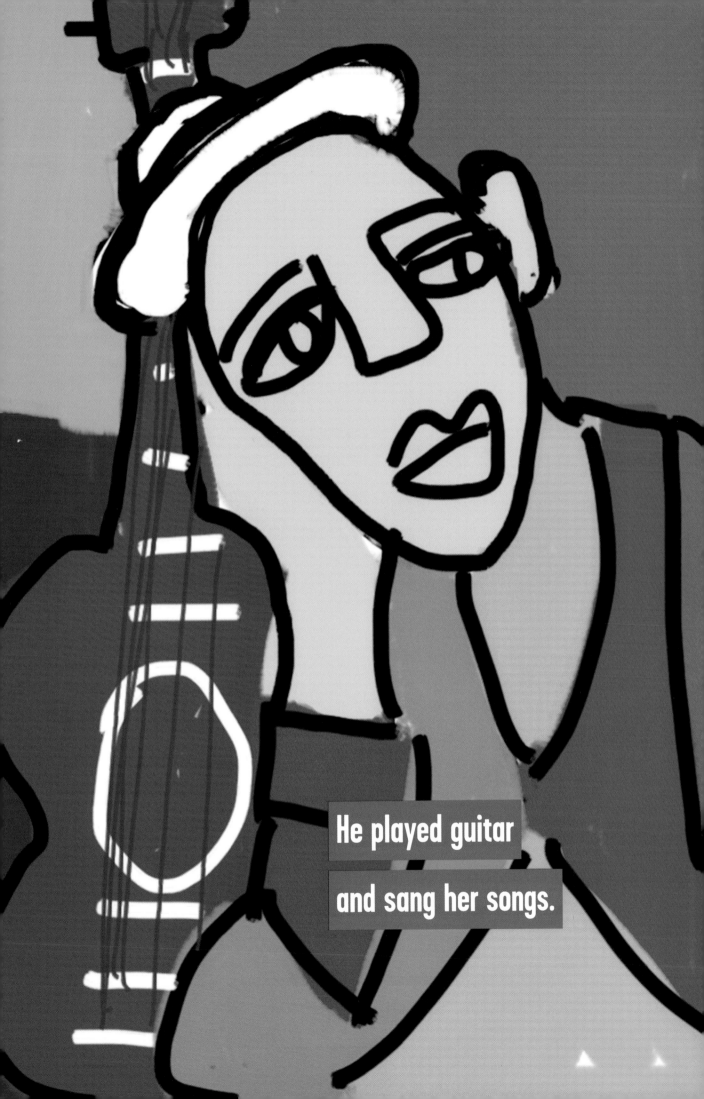

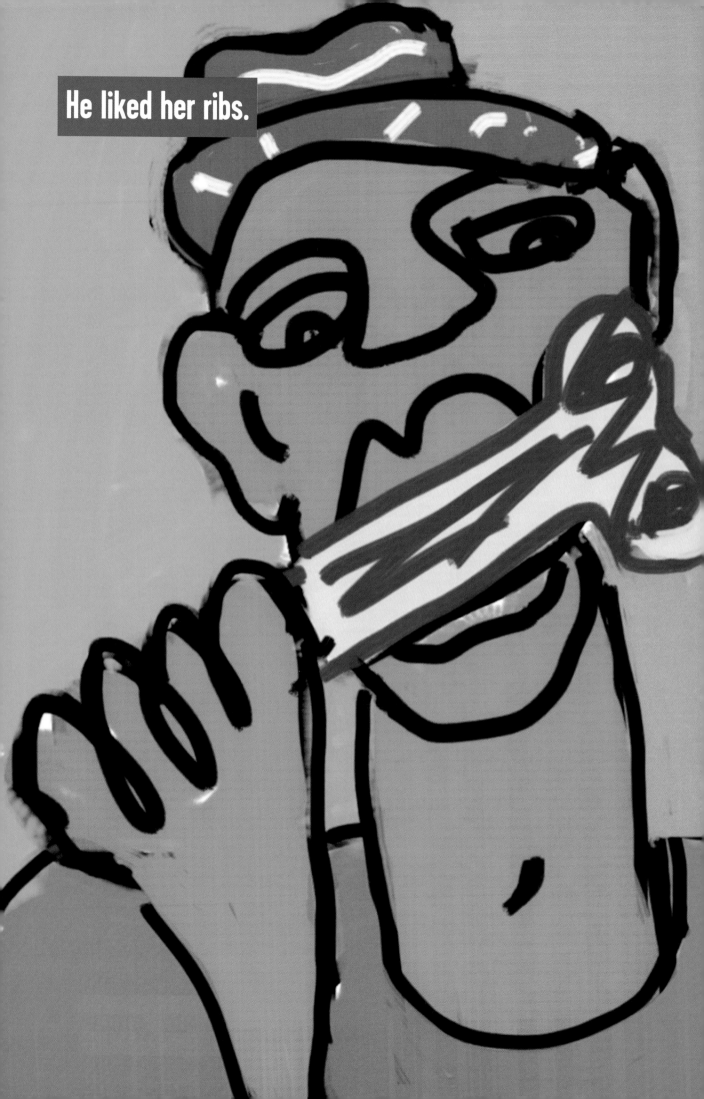

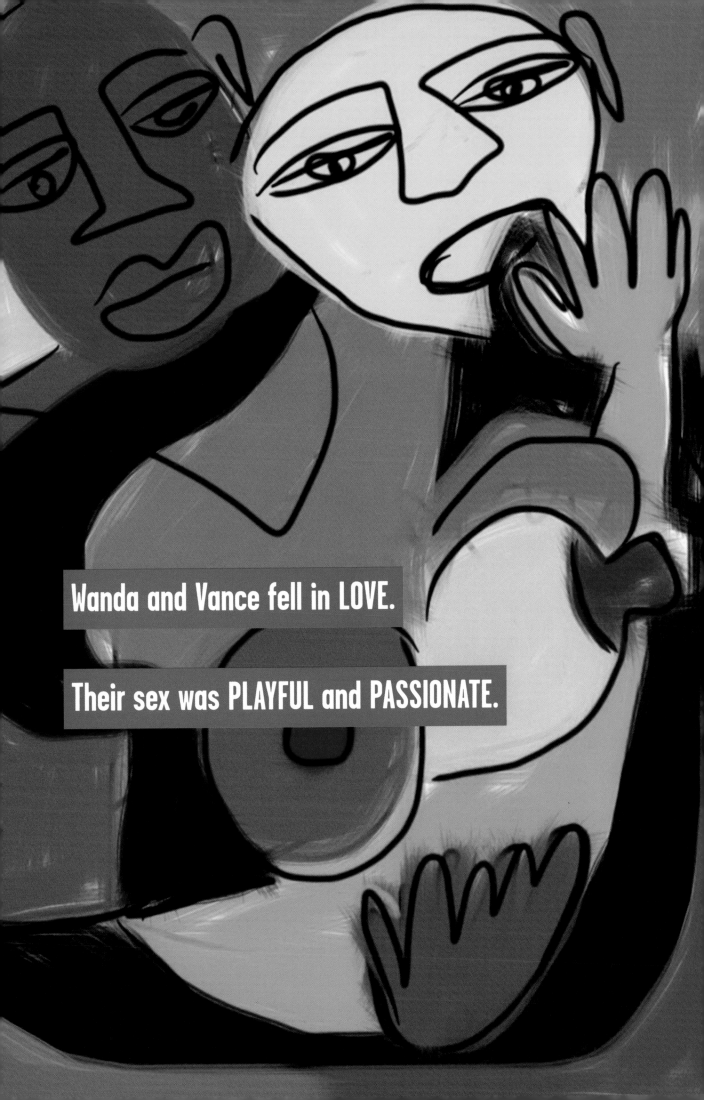

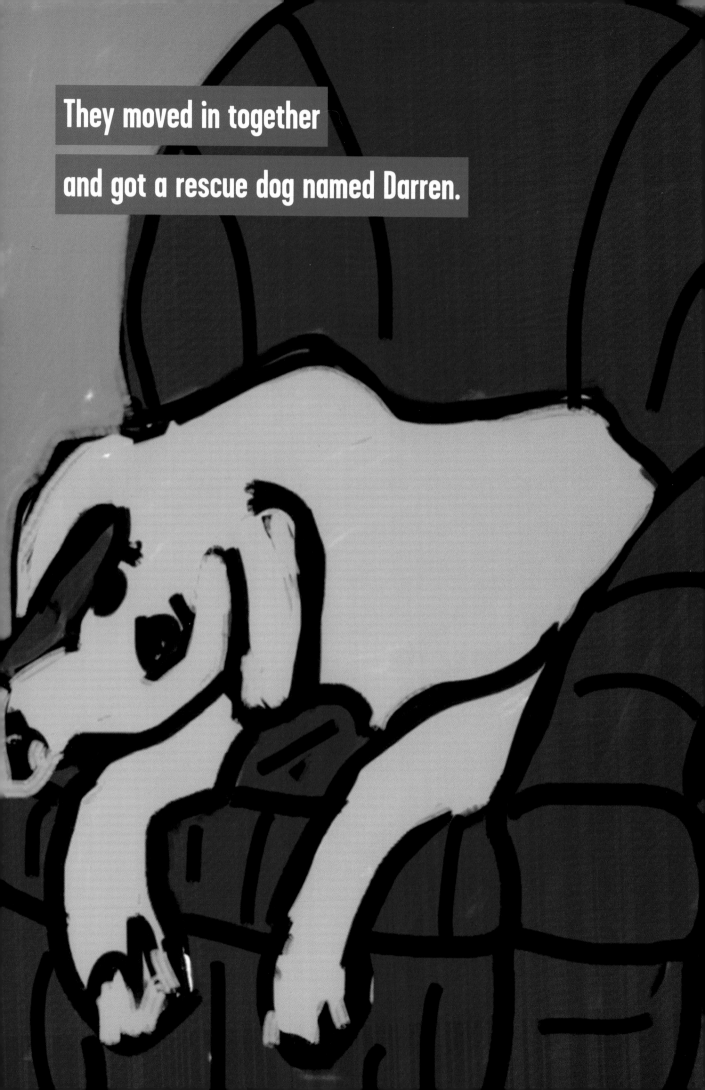

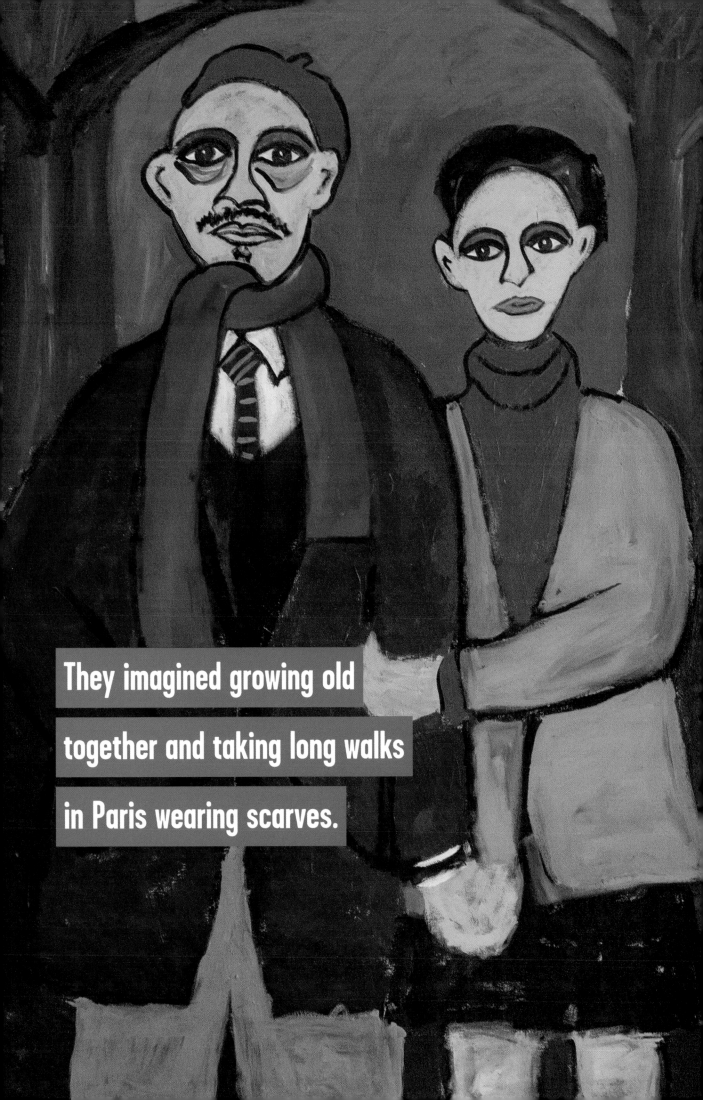

They imagined growing old together and taking long walks in Paris wearing scarves.

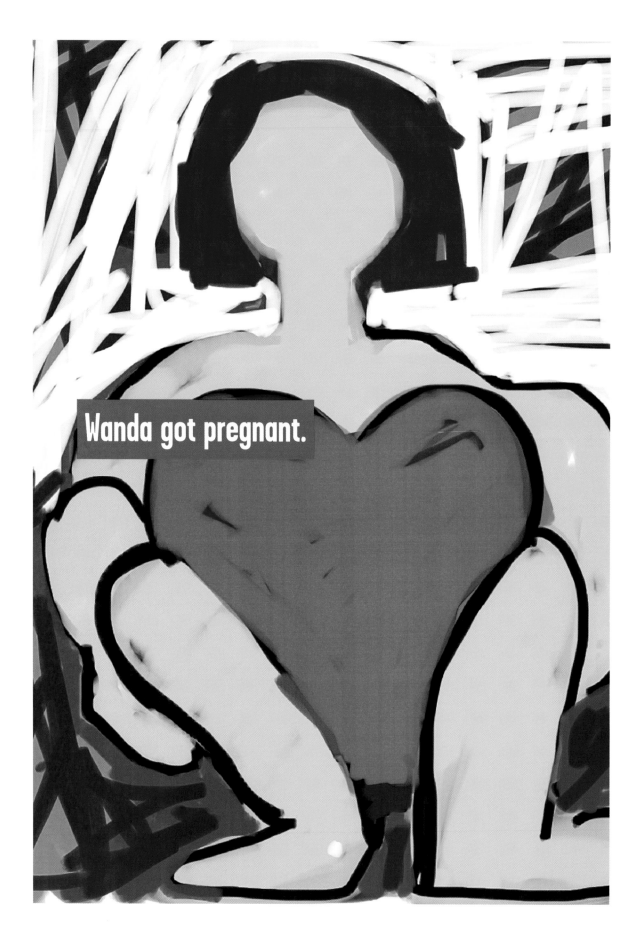

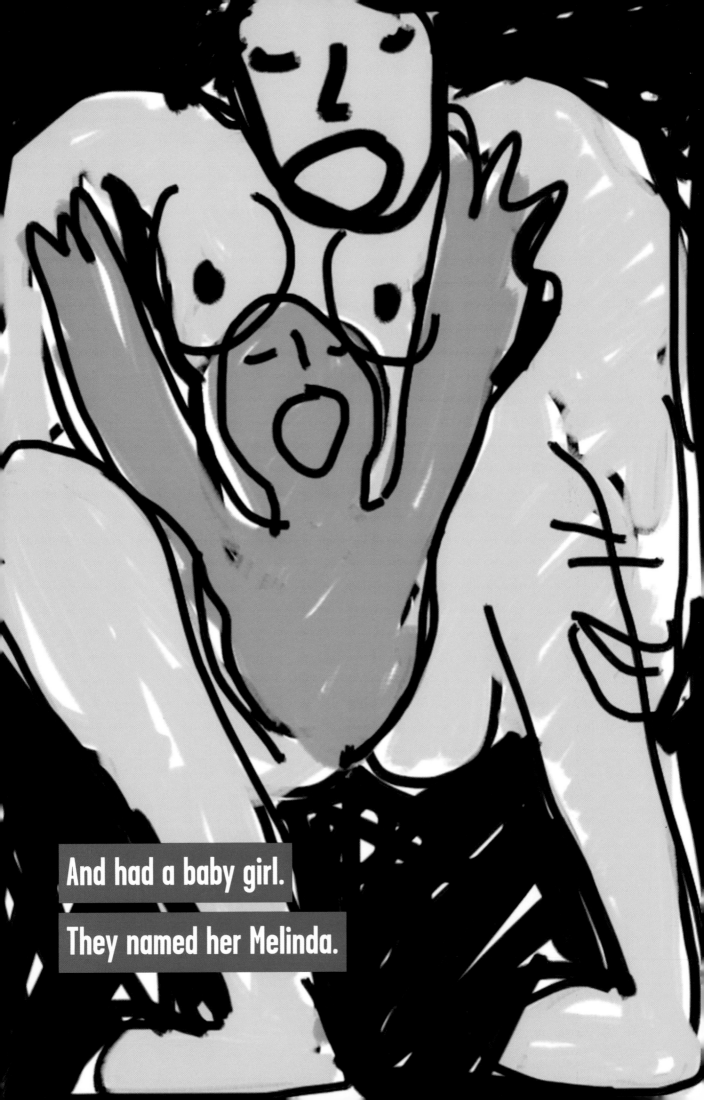

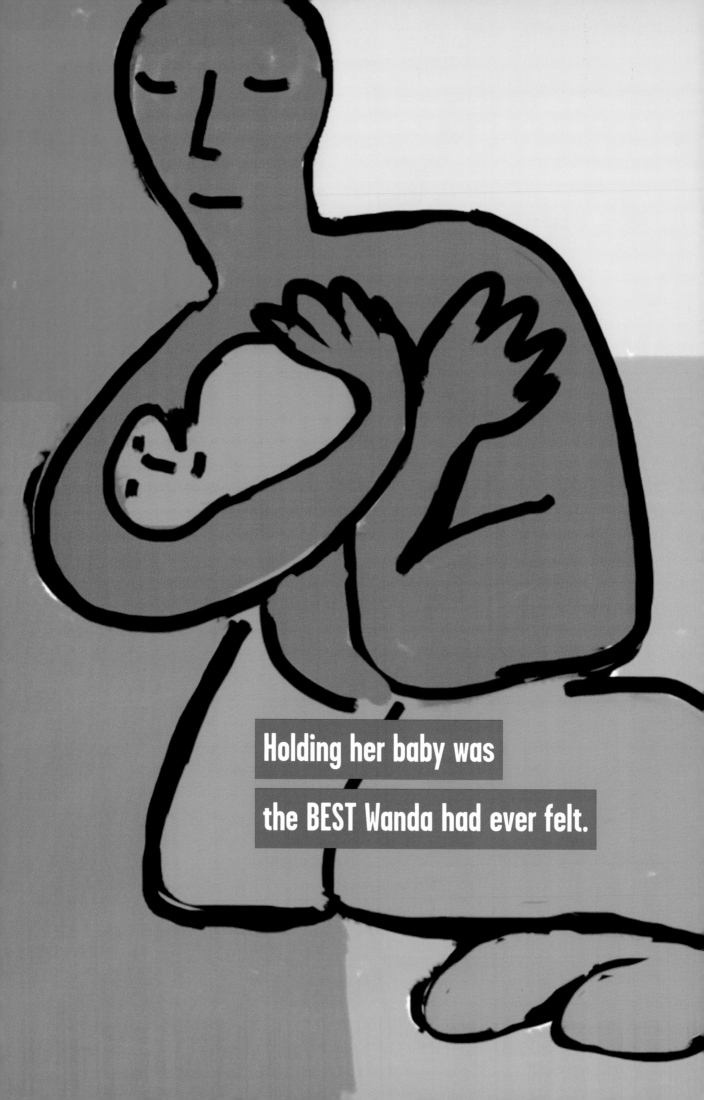

Holding her baby was
the BEST Wanda had ever felt.

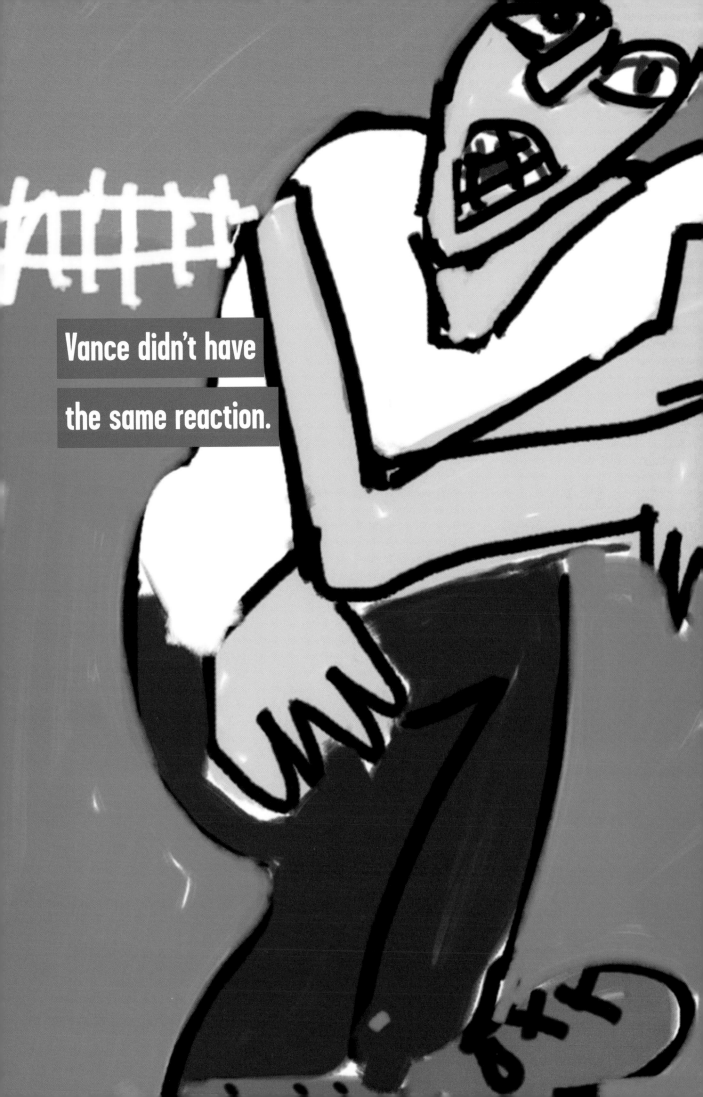

Vance didn't have the same reaction.

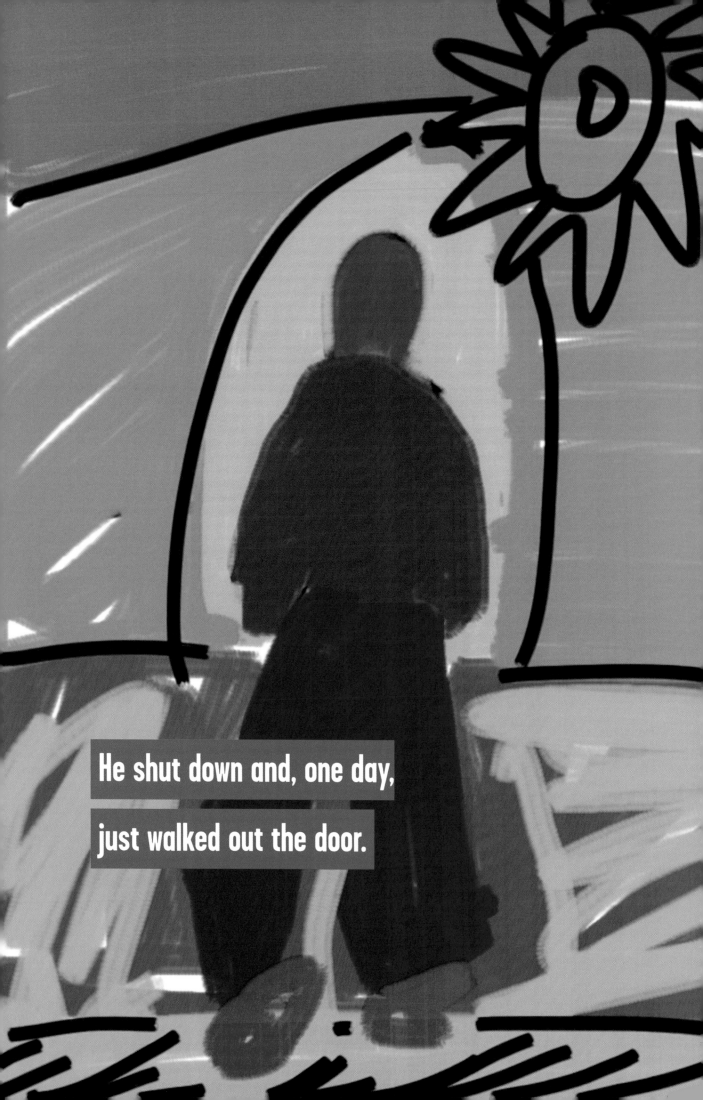

He shut down and, one day, just walked out the door.

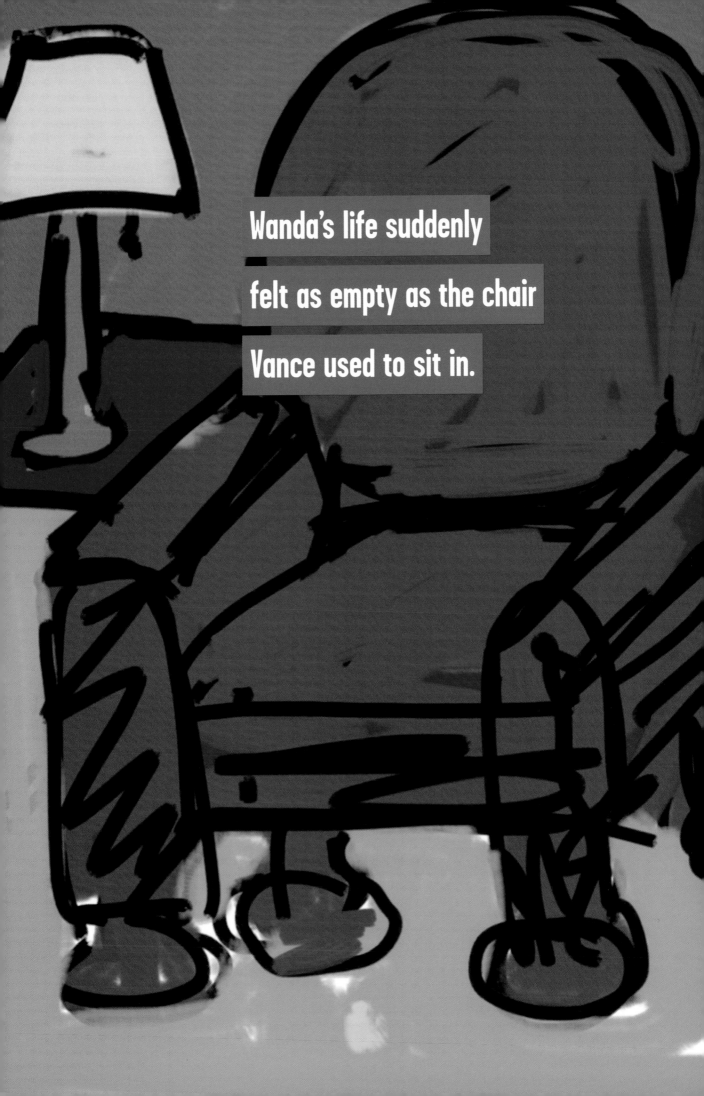

Wanda's life suddenly felt as empty as the chair Vance used to sit in.

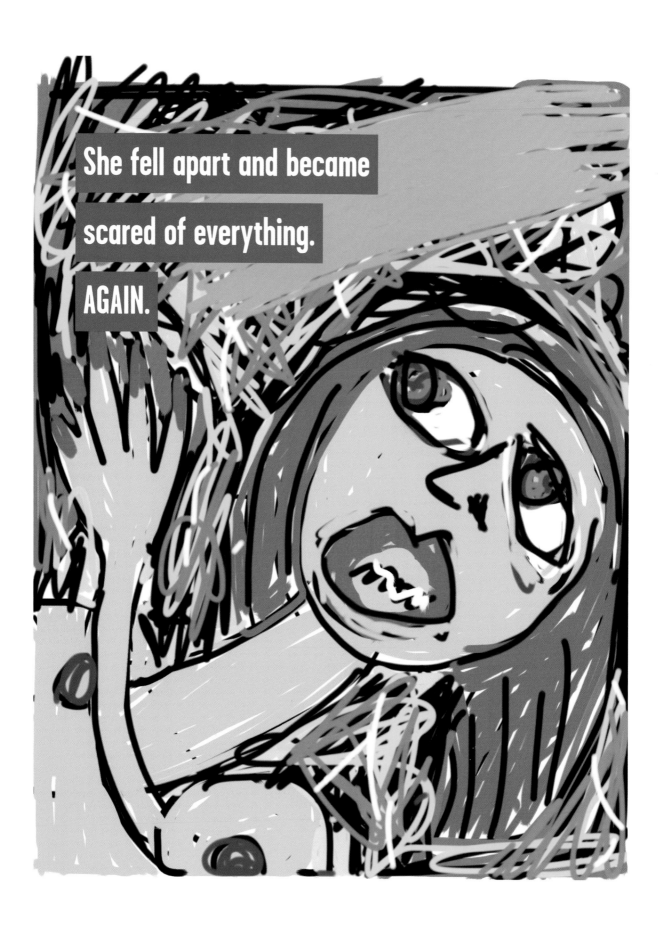

Wanda wanted to be strong
like a Henry Moore sculpture.

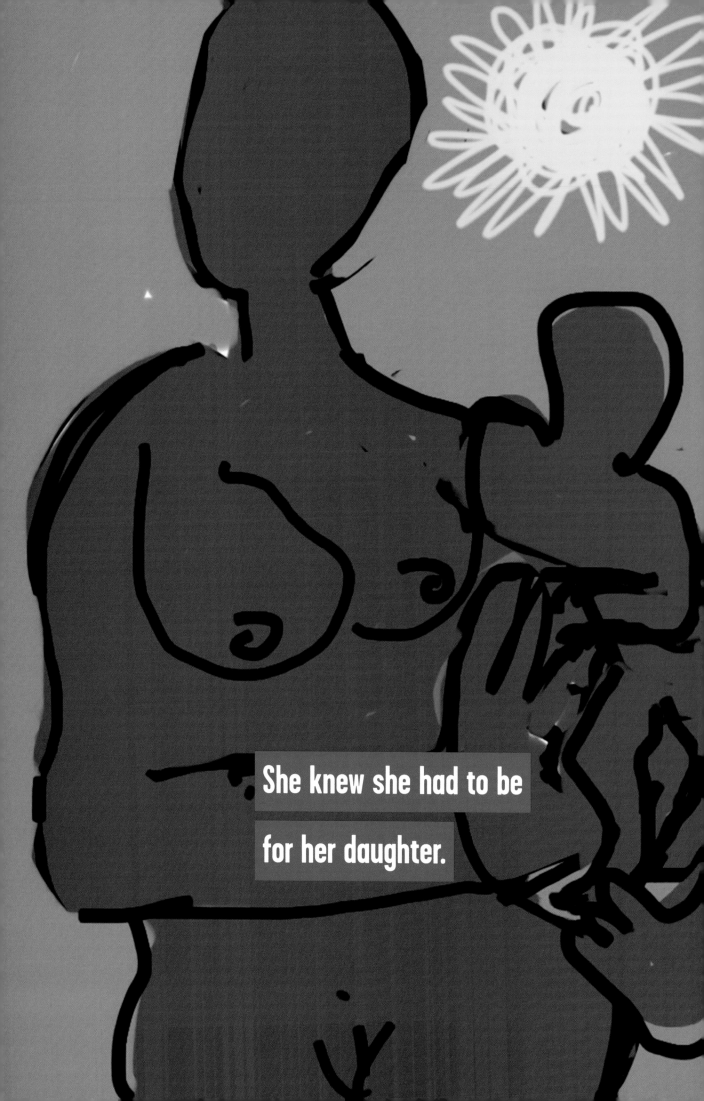

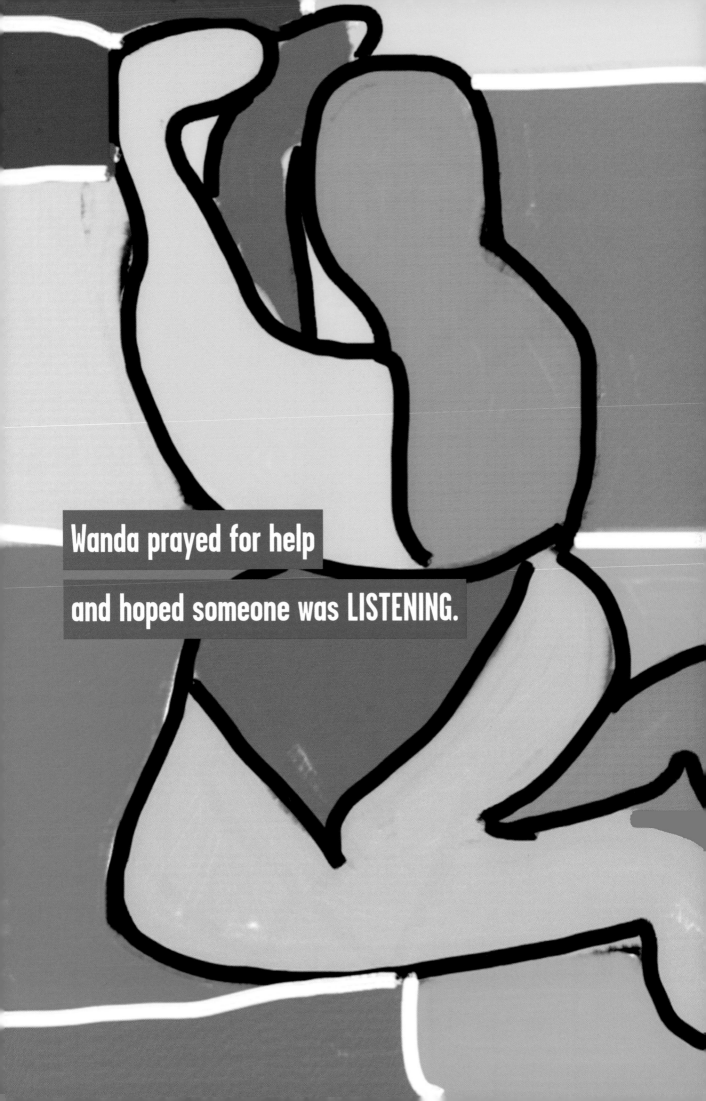

Wanda prayed for help
and hoped someone was LISTENING.

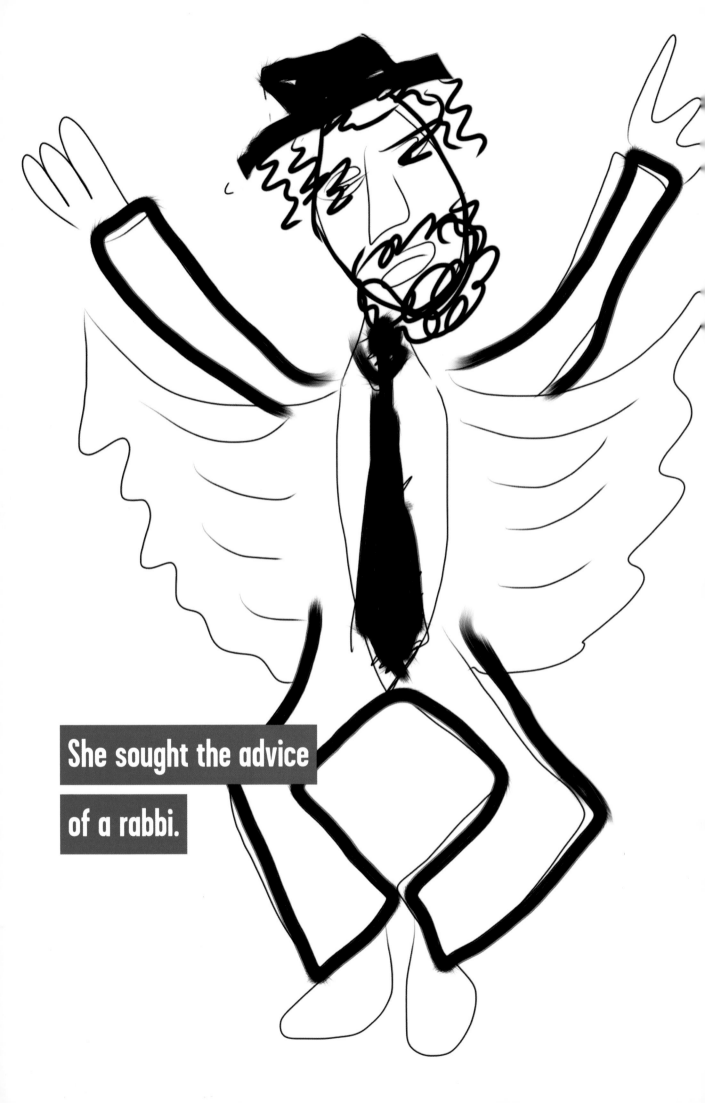

She sought the advice of a rabbi.

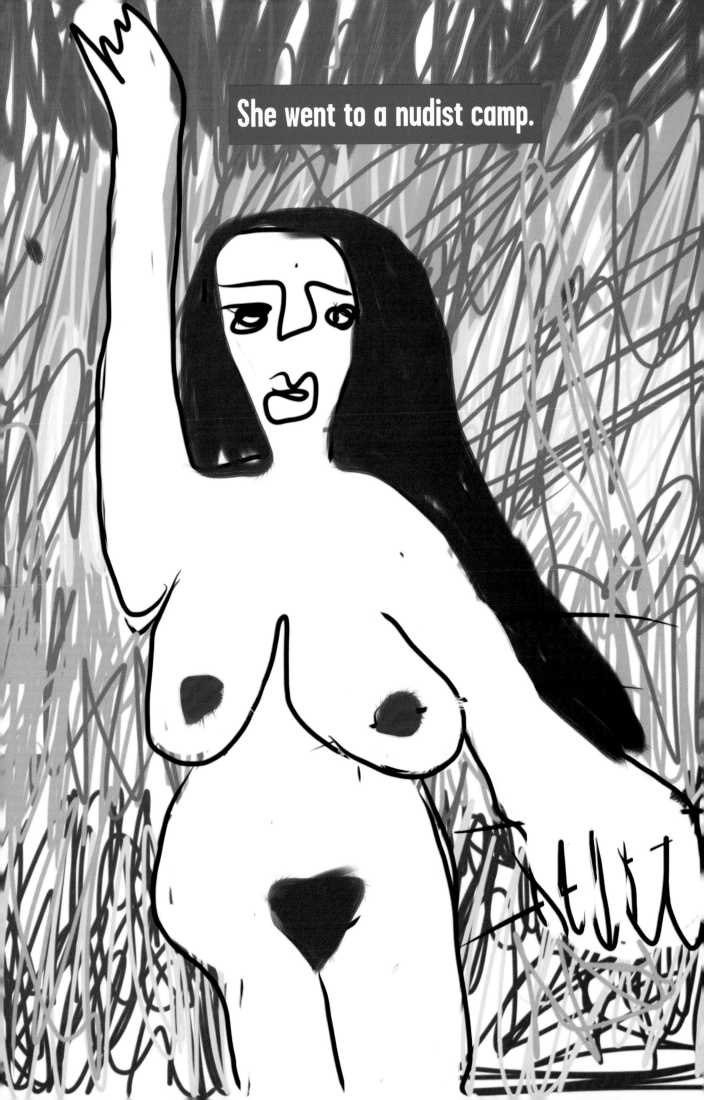

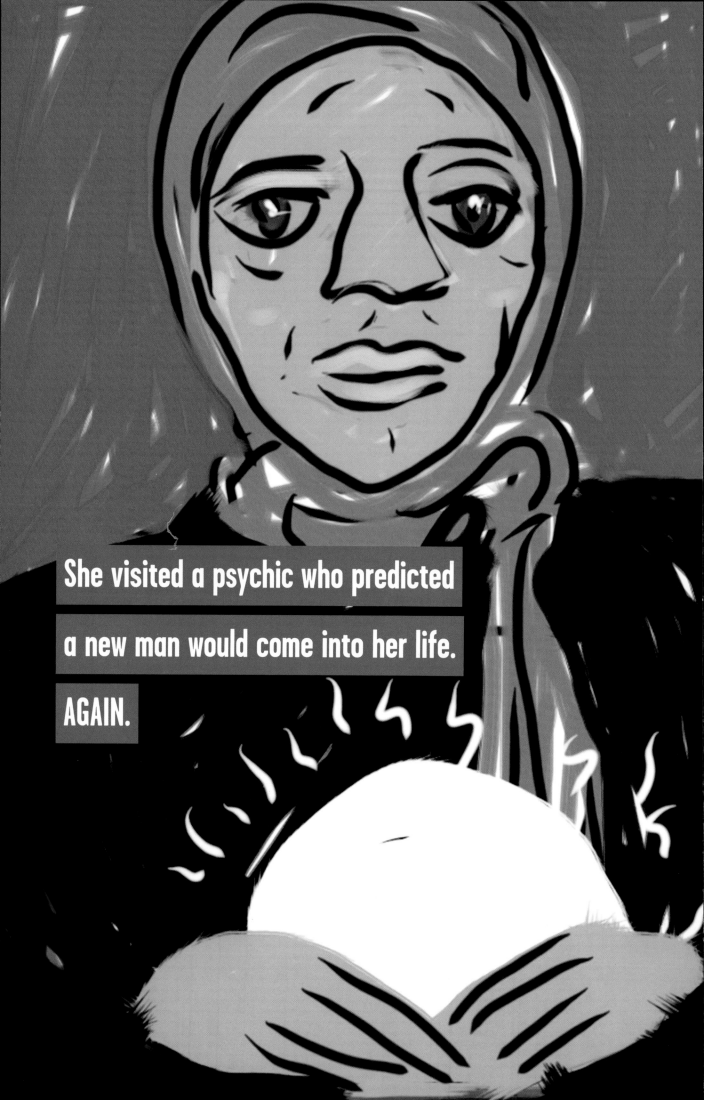

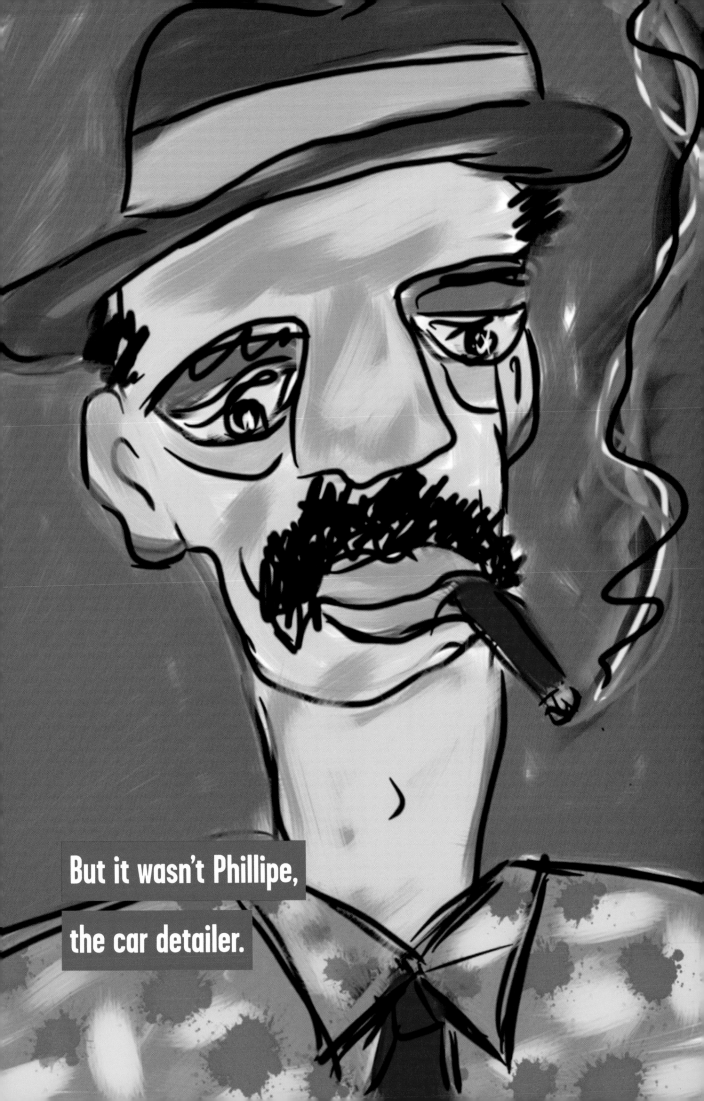

But it wasn't Phillipe, the car detailer.

Julian, the yoga instructor.

Roberto, the poet.

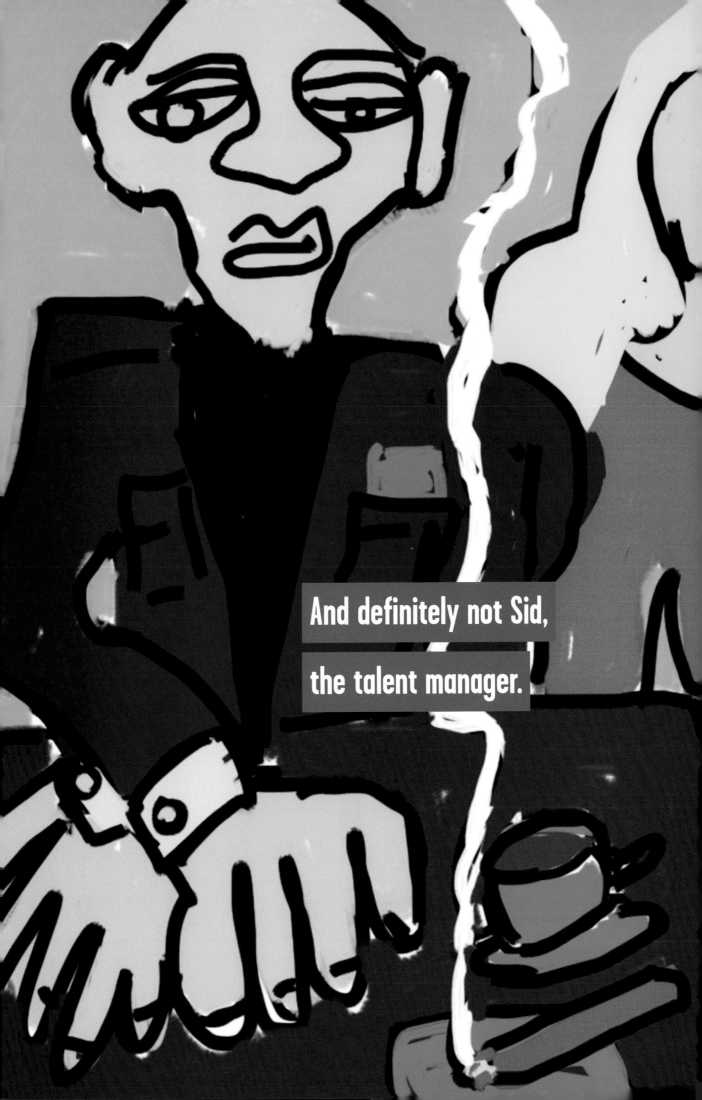

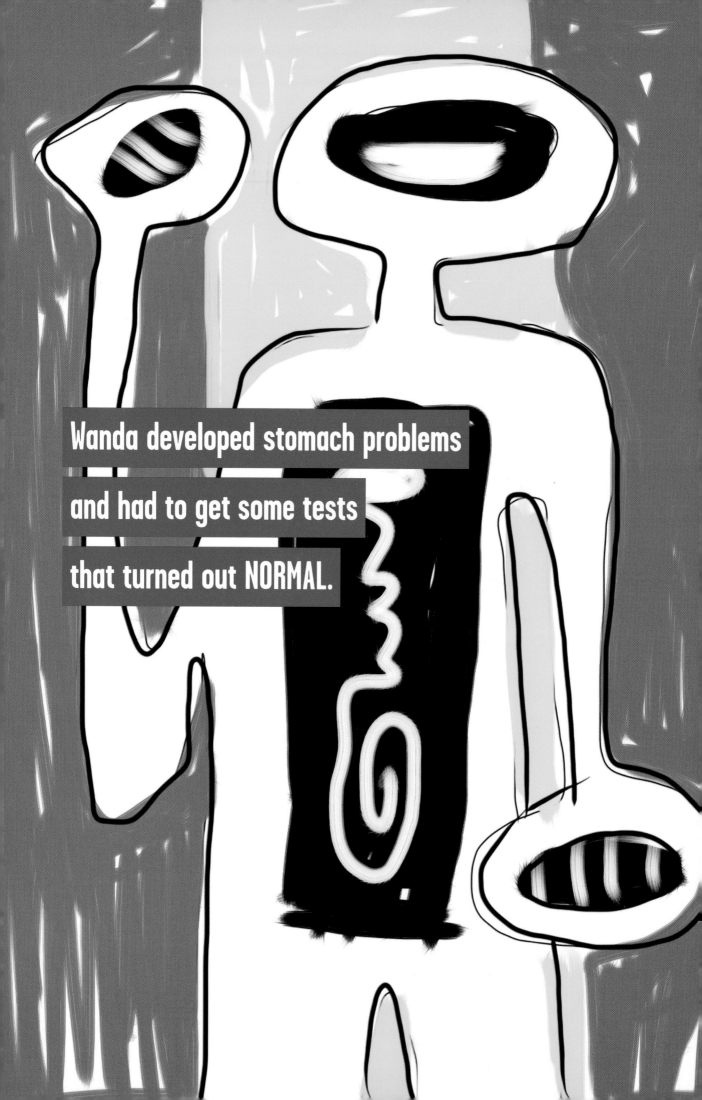

Wanda developed stomach problems and had to get some tests that turned out NORMAL.

Summer came and
Melinda took her first steps.

Wanda began going out.

She went to the symphony.

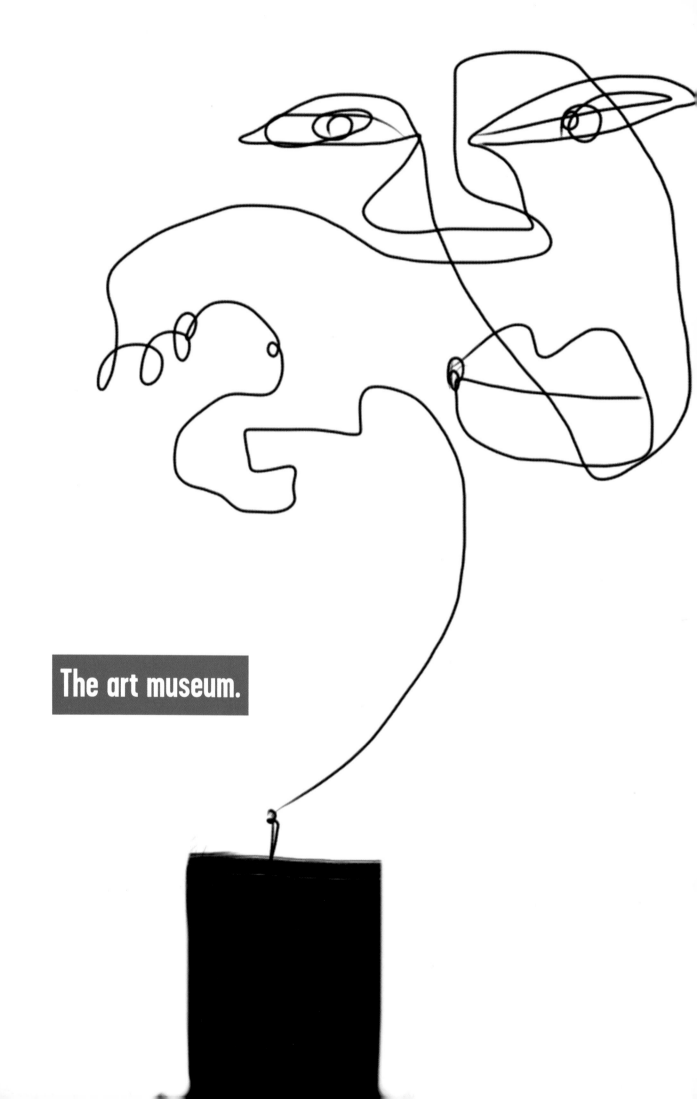

The art museum.

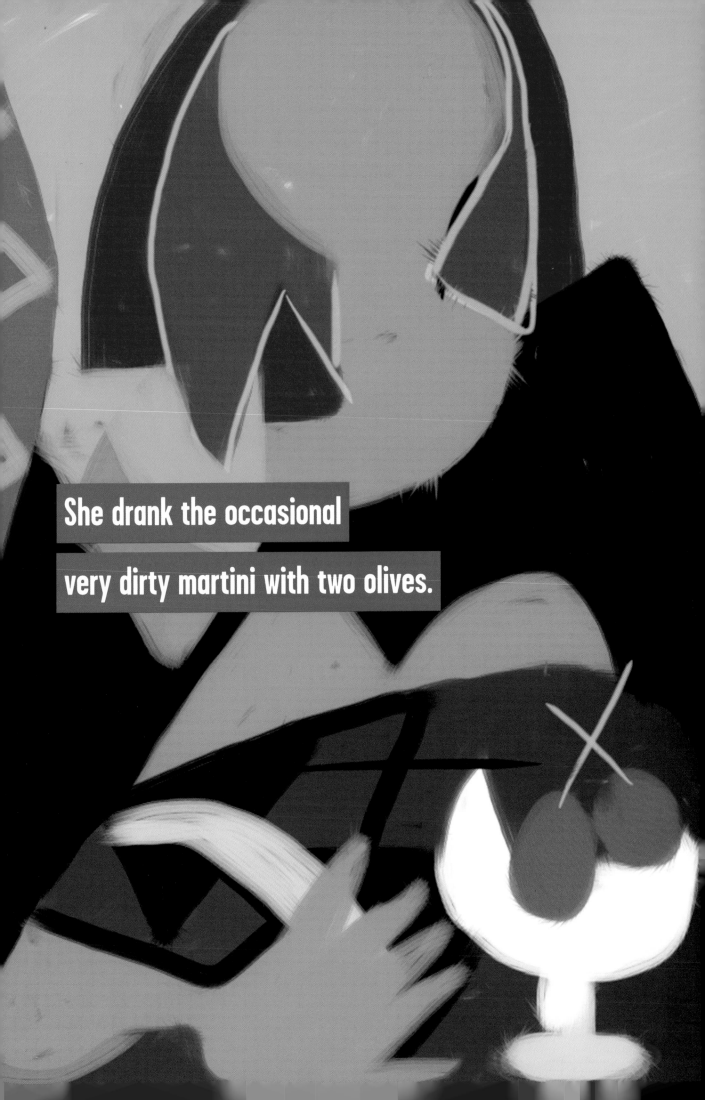

She drank the occasional

very dirty martini with two olives.

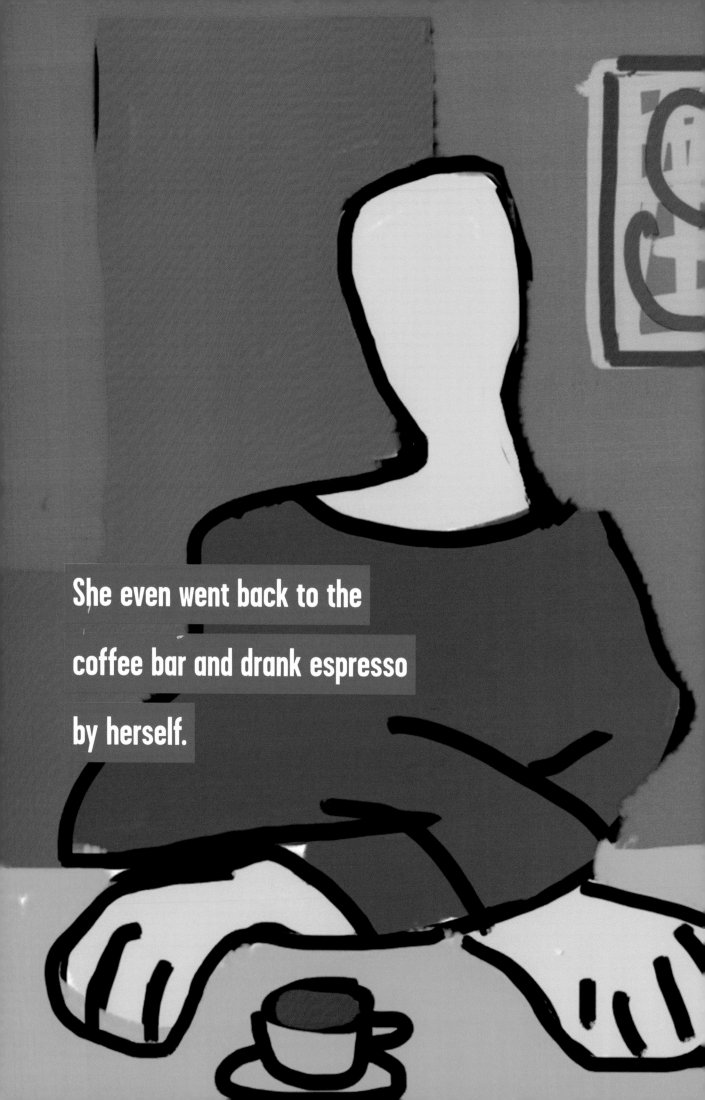

She even went back to the coffee bar and drank espresso by herself.

And then one day
Wanda walked by a mirror
and liked what she saw.

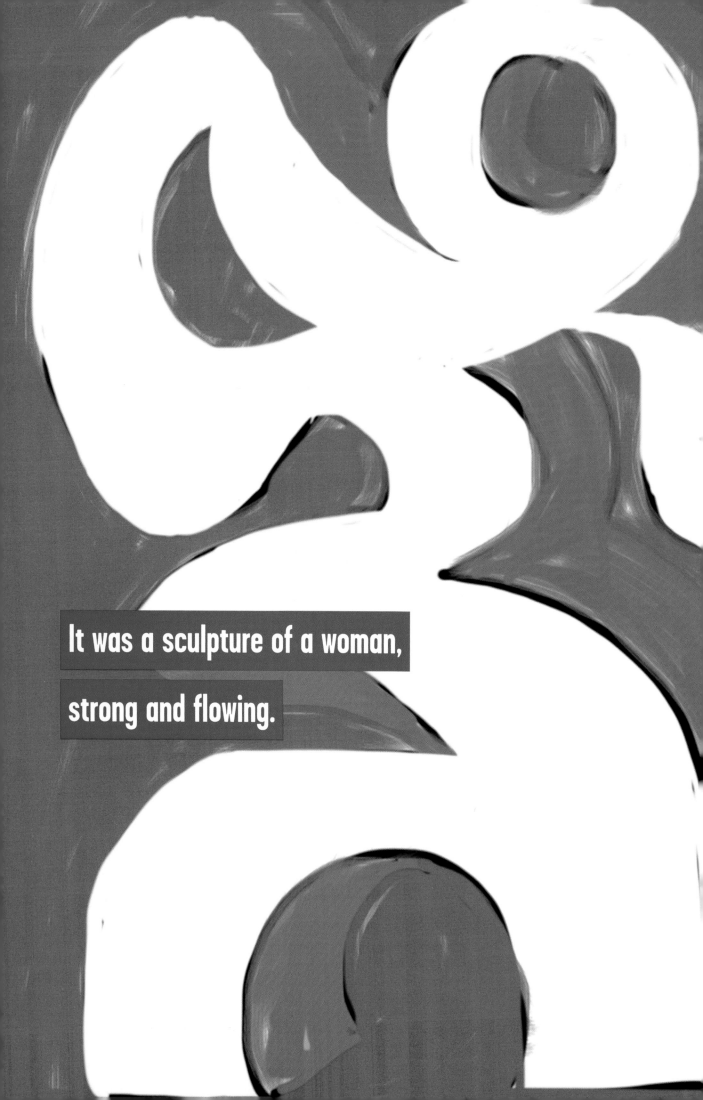

It was a sculpture of a woman,

strong and flowing.

Wanda woke up and felt better.

MY WIFE WAS KILLED BY AN ALLIGATOR

[Taken from the *Florida Grapefruit Gazette*.]

IT WAS A NEAR-PERFECT SPRING DAY IN ST. PETERSBURG, FLORIDA.

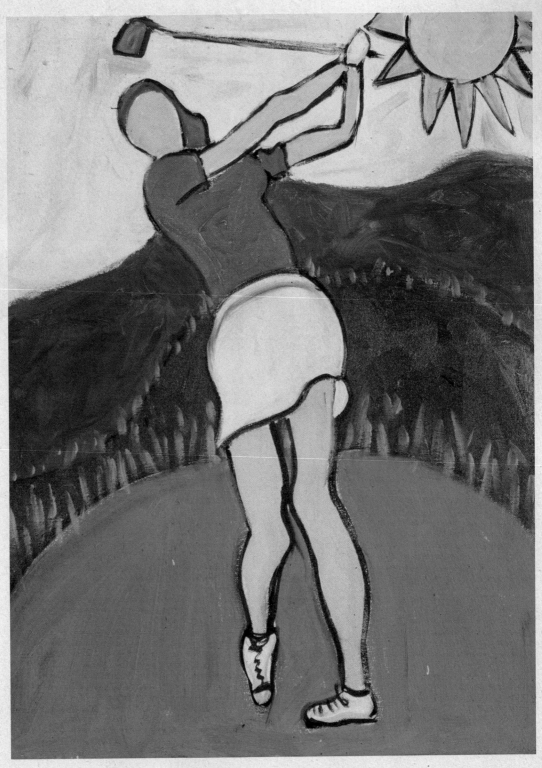

It was only "near" perfect, because as Helen Highwater was finishing a round of golf with her best friends and about to have lunch in the clubhouse . . .

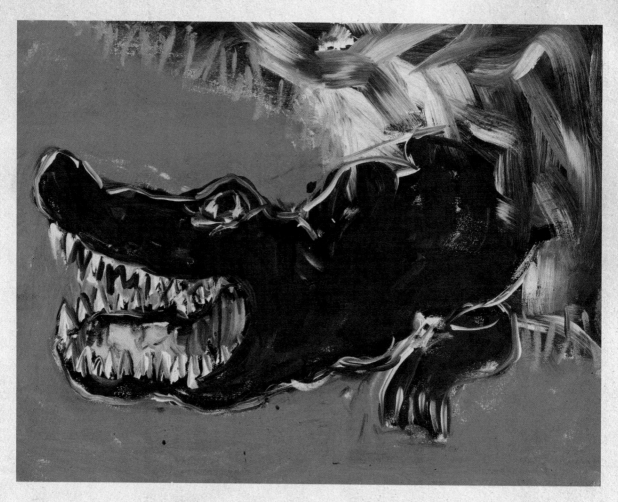

An alligator sprang out of the water next to the ninth hole
and latched onto Helen's lavender and white golf outfit.

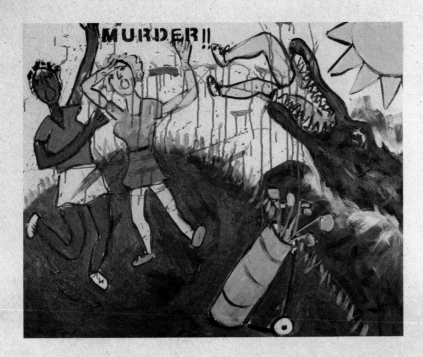

Barb and Trudy watched horrified as their best friend was sliced and diced by eighty razor-sharp teeth and dragged kicking and screaming into the swamp.

THEY WERE GOING TO HAVE A NICE LUNCH. INSTEAD, HELEN WAS LUNCH.

Helen's devoted husband, Hank Highwater, was shattered by the sudden loss. His once-successful life was knocked on its side.

OLD COLLEGE HABITS OF DRINKING AND GAMBLING TOOK HOLD.

Their teenage children began spinning out of control and, without their mother, Hank had no idea how to talk to them.

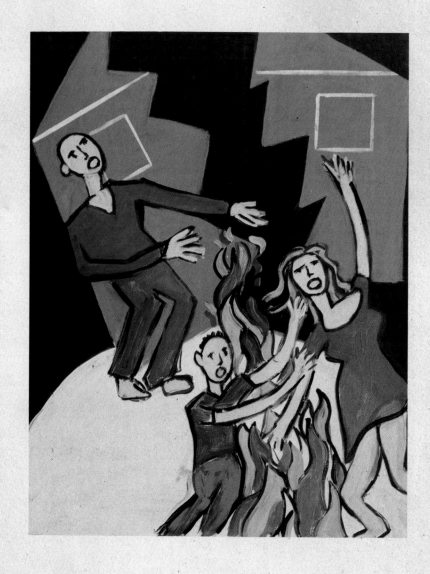

DRIVING HOME ONE NIGHT AFTER TOO MANY BOILERMAKERS, HANK SMASHED HIS FORD TAURUS INTO A PALM TREE.

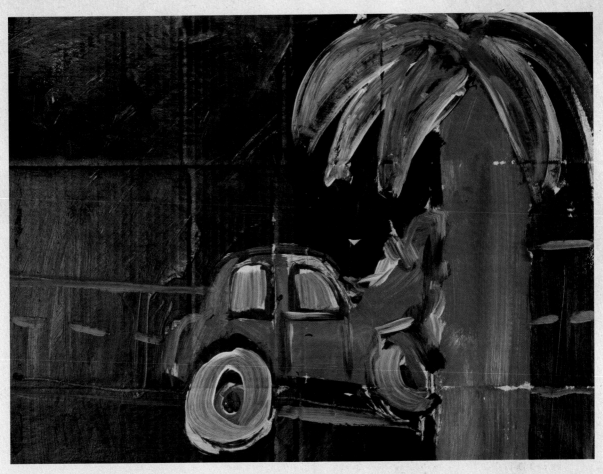

The next day, while Hank was lying comatose in a hospital bed, an old Cuban janitor came into his room.

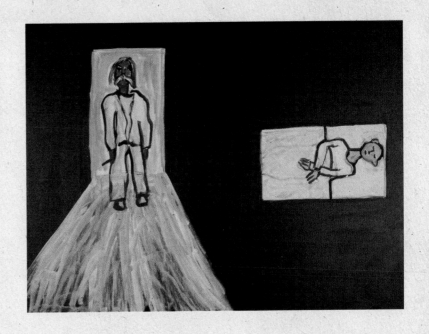

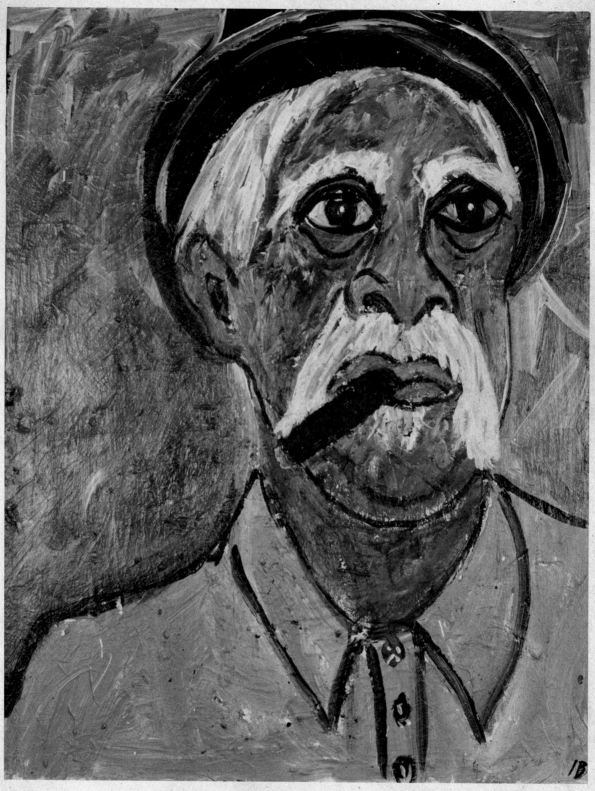

Eduardo had a long white moustache and smoked a
Cohiba Robusto. Hank wondered how you could smoke a
cigar in a hospital. Eduardo leaned in close and whispered
in Hank's bandaged ear. "The alligator killed your wife.
Now you must kill the alligator."

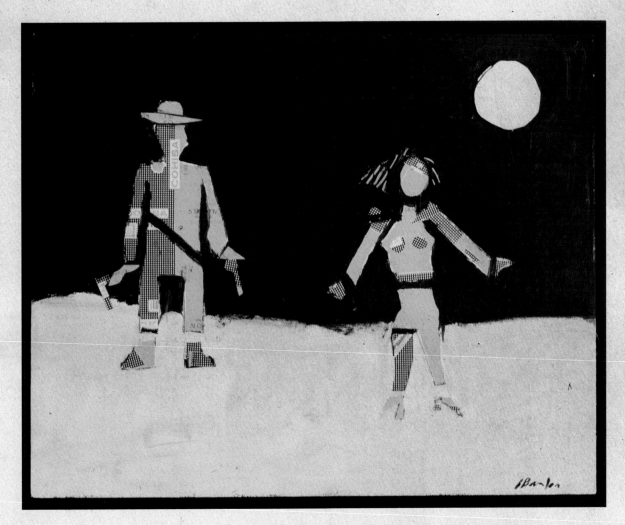

A FEW DAYS LATER, HANK LEFT THE HOSPITAL WITH EDUARDO'S MANTRA RINGING IN HIS EAR AND A NEWFOUND MISSION TO HUNT DOWN HIS WIFE'S KILLER.

He trained like a middle-aged man who decided to climb Everest. Eating vegan and daily cardio workouts were his new regimen.

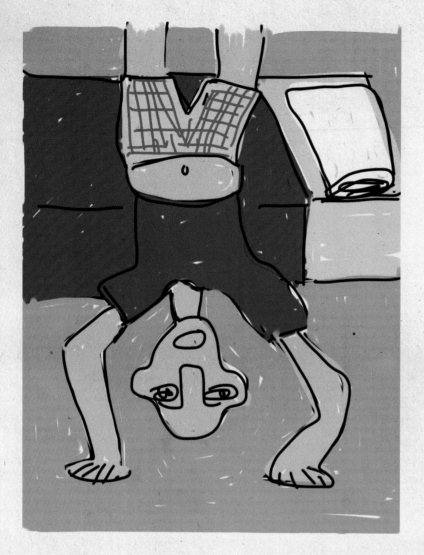

Hank studied the area surrounding the golf course on Google Maps to zero in on where his wife's murderer would most likely be.

THE DAY OF REVENGE FINALLY CAME.

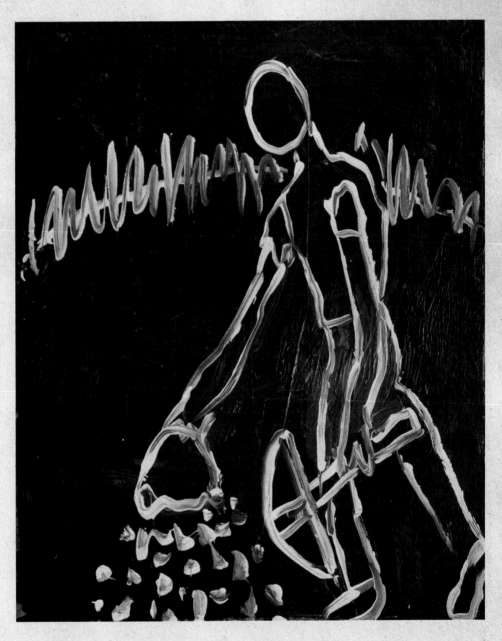

Wearing camo pants and a T-shirt he had made with Helen's smiling face on it, Hank downed his protein shake and headed out.

Like SEAL Team Six moving in on the bin Laden compound, Hank silently approached the swamp and laid out the raw hamburger meat he had bought at the Piggly Wiggly.

IT DIDN'T TAKE LONG FOR THE SCENT OF THE MEAT TO DRAW THE MONSTER OUT OF THE MURKY WATER.

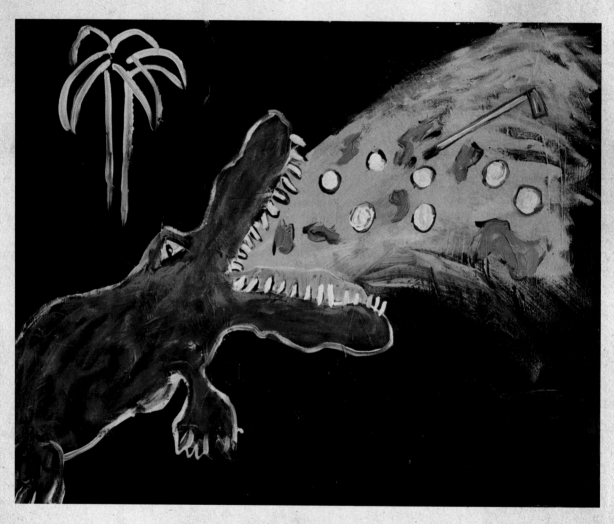

In order to make room for the feast before him, the alligator opened his huge mouth and vomited up golf balls, shredded pieces of Helen's lavender clothes, and even the putter Hank had bought her last Christmas.

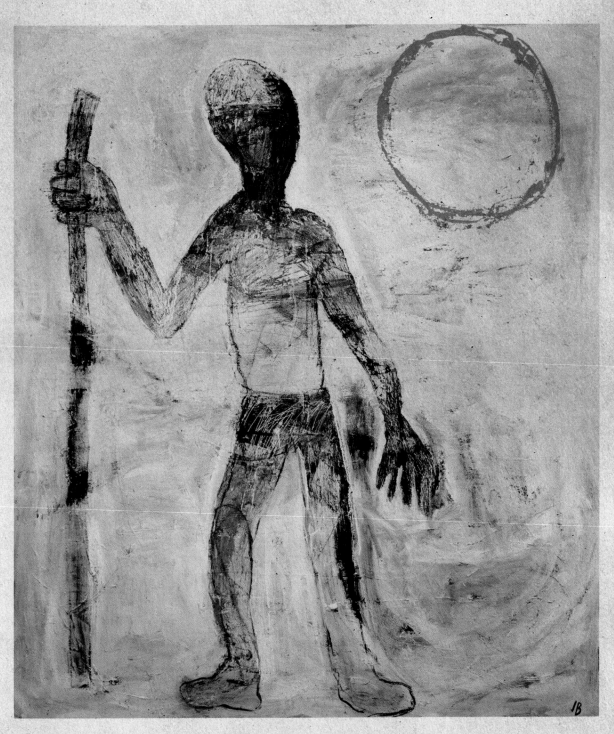

LIKE THE PRIMORDIAL MAN
WITHIN HIM, HANK STOOD UP.

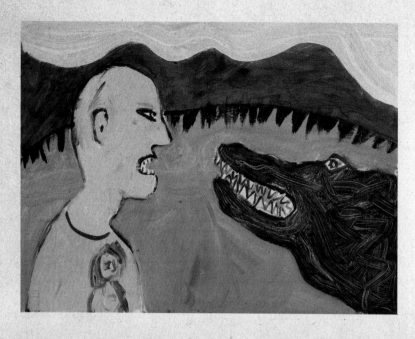

The alligator jerked back
on his short strong legs,
shouting, "Don't shoot!"

Hank snapped back doing
his best Clint Eastwood.
"You killed my wife."

"Oh, yeah, sorry 'bout that."

"Sorry about that?!" yelled
Hank so loud a flock of
Florida scrub jays flew out
of the reeds.

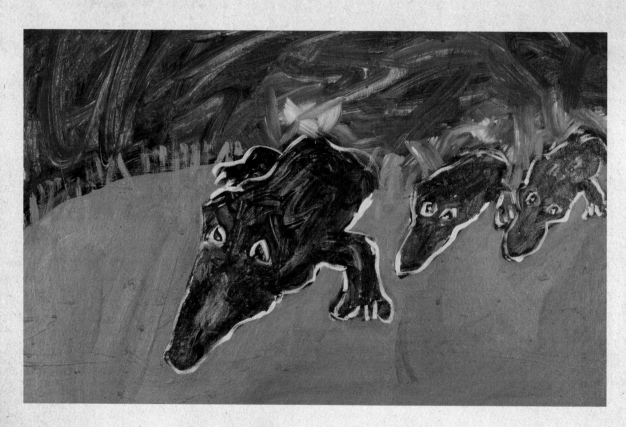

Just then three more alligators came out of
the swamp. "Hey, man, I was just feeding
my family," he said, pointing his short leg
toward his gator wife and kids. "You got any
kids of your own?"

"Yeah, now motherless, thanks to you, asshole."

"Daddy . . . ?" the alligator kid whimpered.

"It's okay, guys. Go back into the swamp with
your mother."

LEFT ALONE, THE TWO FATHERS FACED OFF LIKE GUNFIGHTERS AT HIGH NOON.

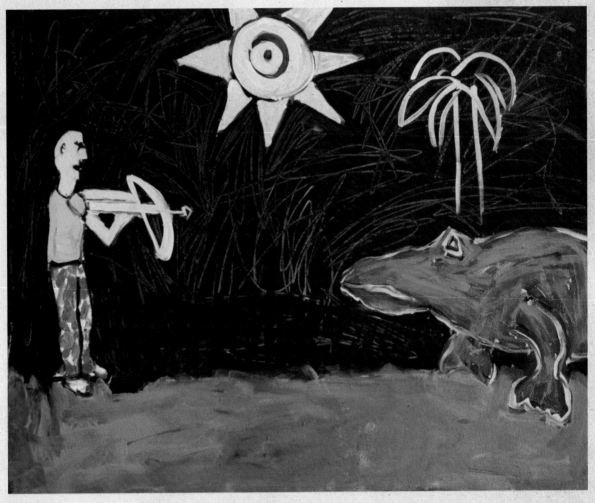

Hank aimed the crossbow right between the alligator's green beady eyes. "You gonna eat me? Make some fancy boots or a nice belt?" the alligator asked.

"Hell no, I donate to PETA!" Hank snapped back, anxious to get on with it.

"Then what's the use? You humans kill for fun, we kill to survive."

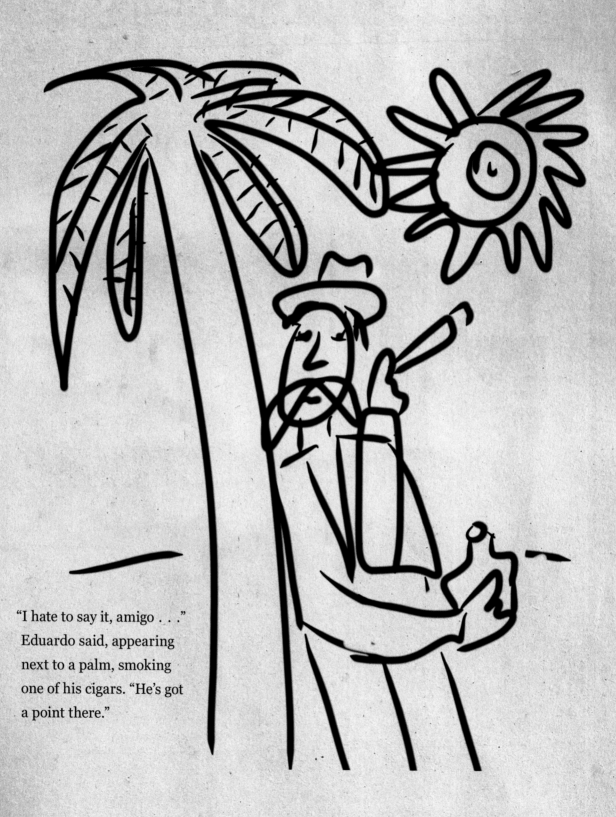

"I hate to say it, amigo . . ."
Eduardo said, appearing
next to a palm, smoking
one of his cigars. "He's got
a point there."

BY THE TIME HANK LOOKED BACK TO THE SWAMP THE ALLIGATOR WAS GONE.

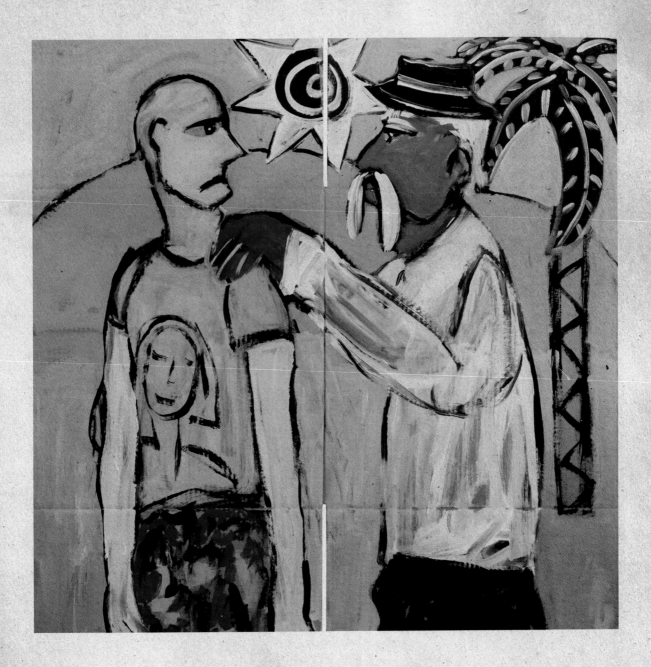

"You were the one who convinced me I had to do this!" Hank shouted.

Eduardo walked over to his friend and put a hand on his shoulder. "Sí, I did. You needed to go through it. But an eye for an eye only makes you half-blind. Go home, *carnal*. Your kids are waiting."

HANK TOOK HIS FRIEND'S ADVICE AND WENT HOME.

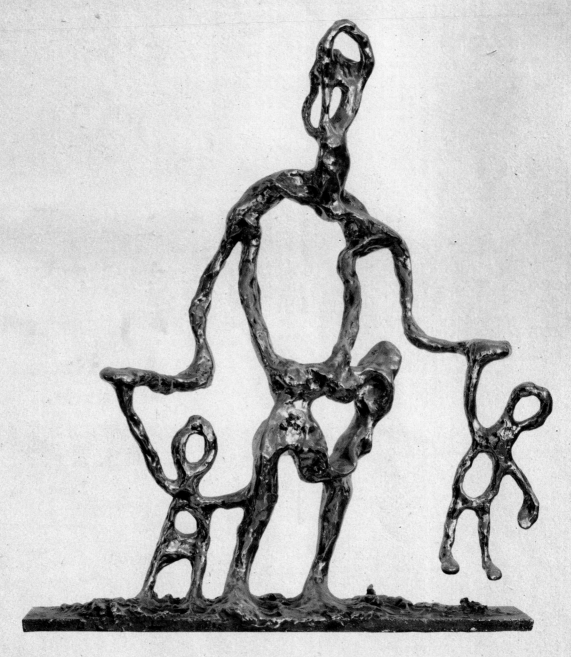

His kids were there. They made dinner together and, for the first time in years, they actually talked.

WHO WE ARE

In the womb
we know who we are.

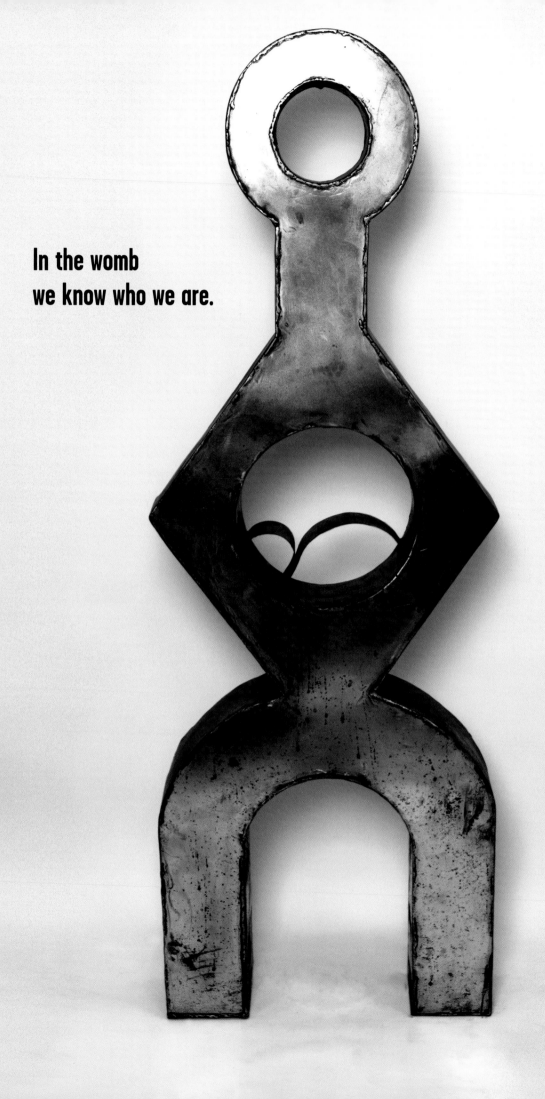

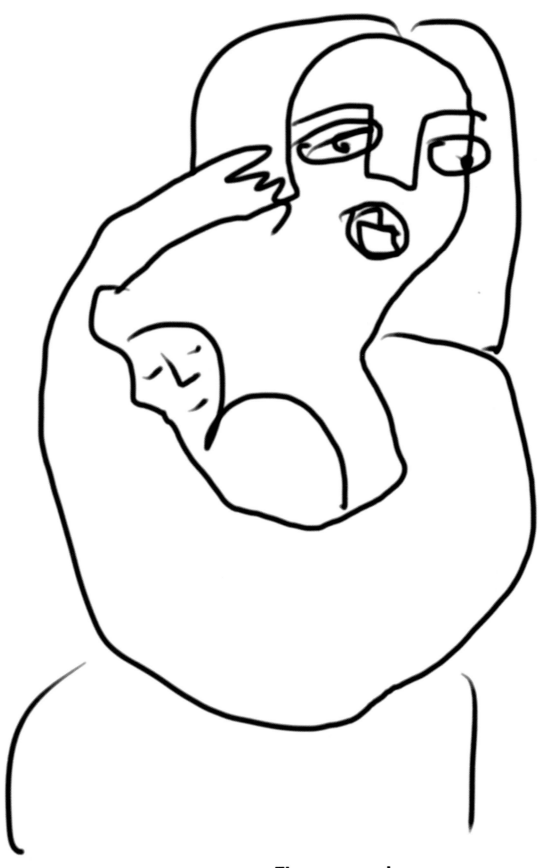

Then we are born
and forget.

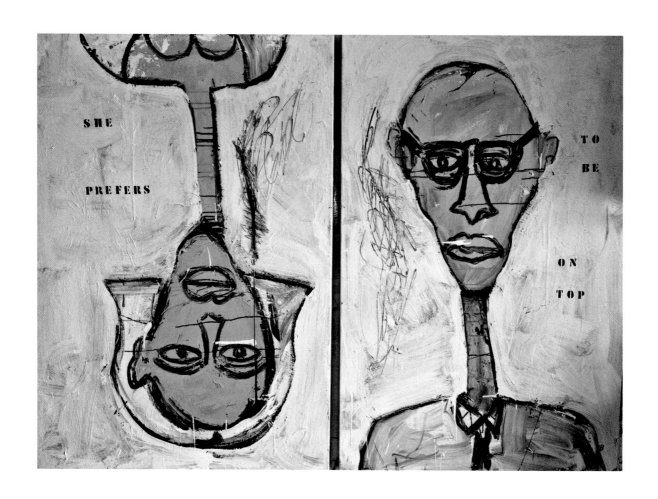

We get the parents we get
and they get us.

Until they don't.
Like my father didn't get me.

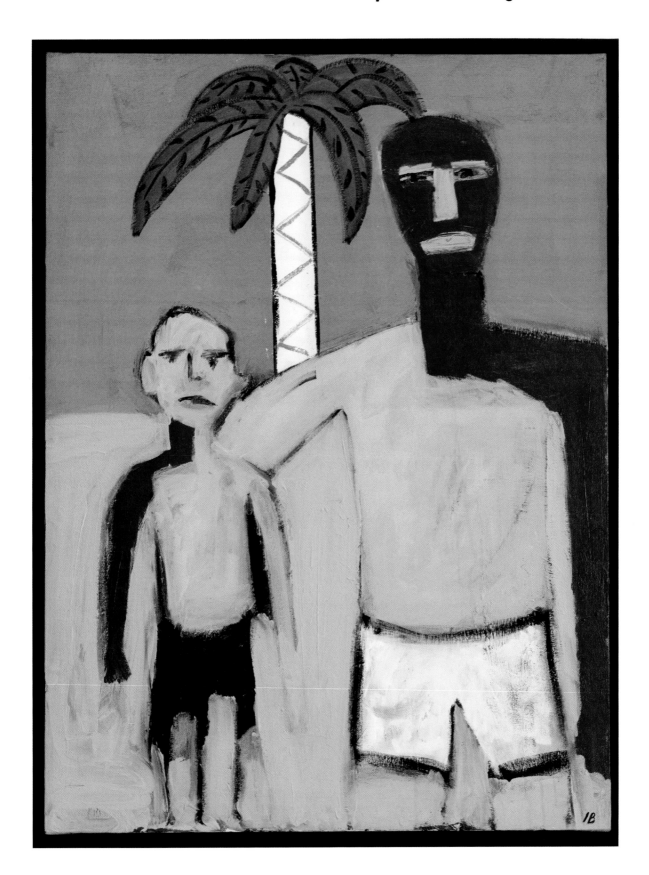

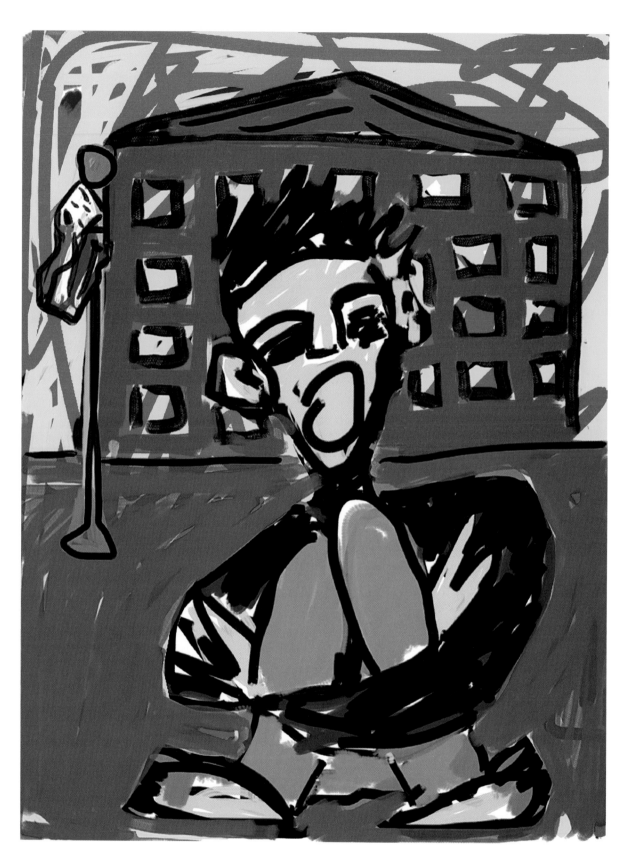

Neither did my teachers.
I couldn't sit still in school.

I was tested for ADHD, bipolar, and borderline personality disorder.

I had none of it. I just didn't fit.

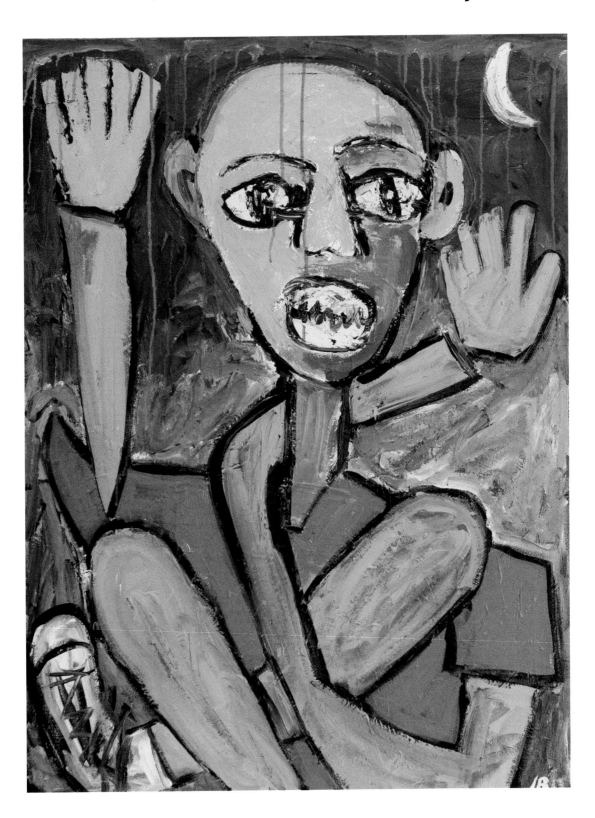

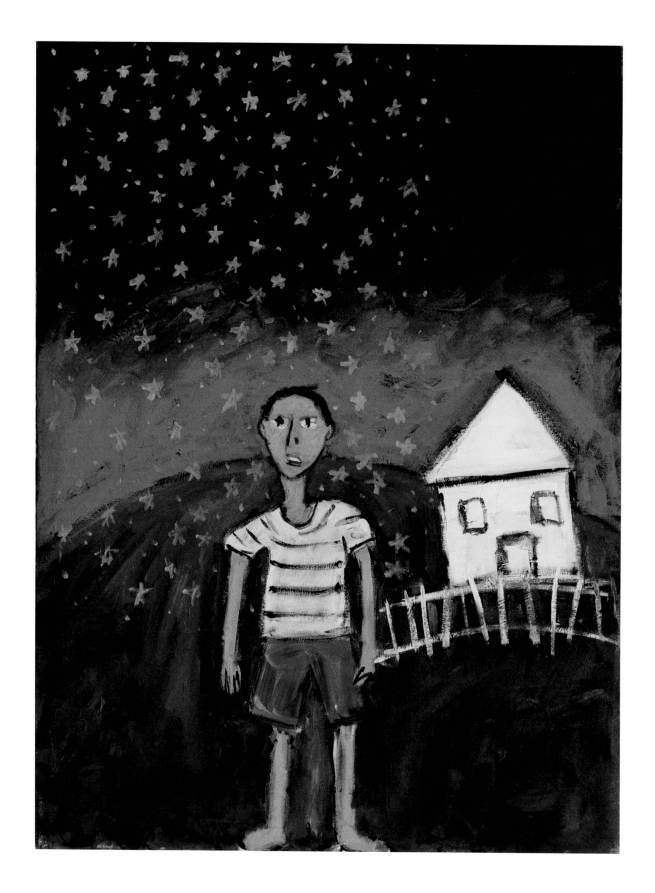

I continued to be an awkward kid
searching for who I was.

That's when I met my uncle Moe. Dad's brother was the round peg in the square hole of our family. He didn't fit either. Moe used to be a bookie and now owned a jazz club.

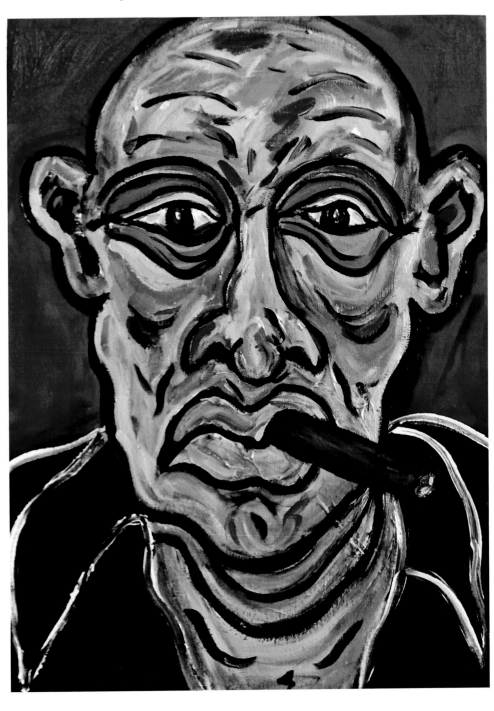

My dad never knew it, but when I got old
enough Uncle Moe's became my place. I loved
hanging out with the musicians.

And the poets.

**The music they made didn't fit any logical pattern.
It felt like me.**

I went off to college.

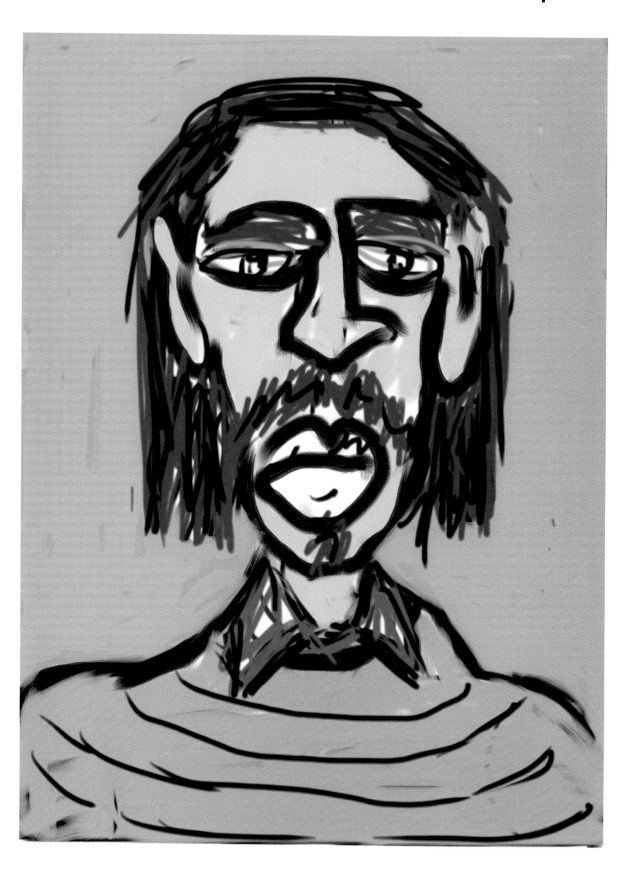

My first girlfriend, a drama student named Sonya,
turned me onto the *Kama Sutra* and Carl Jung.

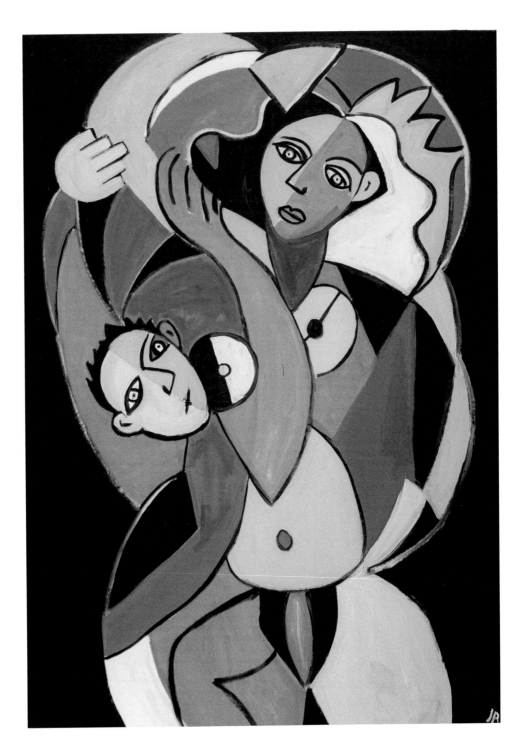

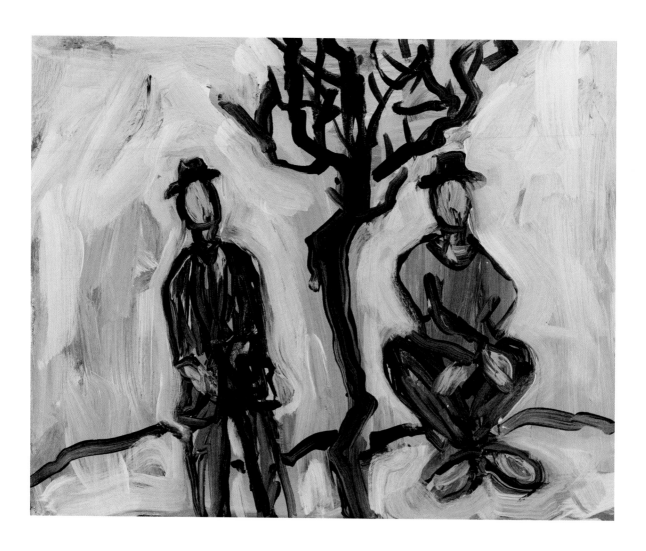

She took me to a production of *Waiting for Godot*. I related to those guys just waiting around for someone to tell them who they were.

My father didn't approve of the direction I was heading and insisted I become a business major.

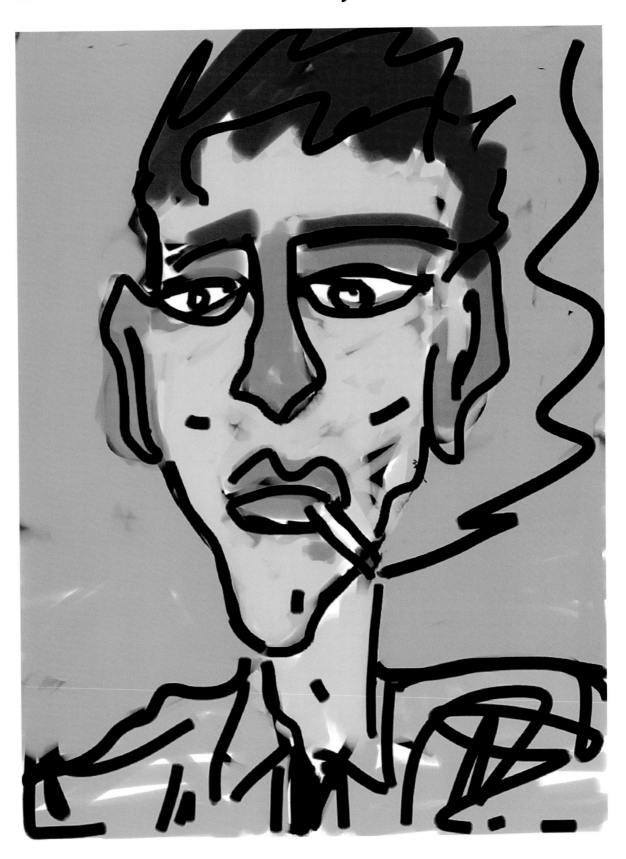

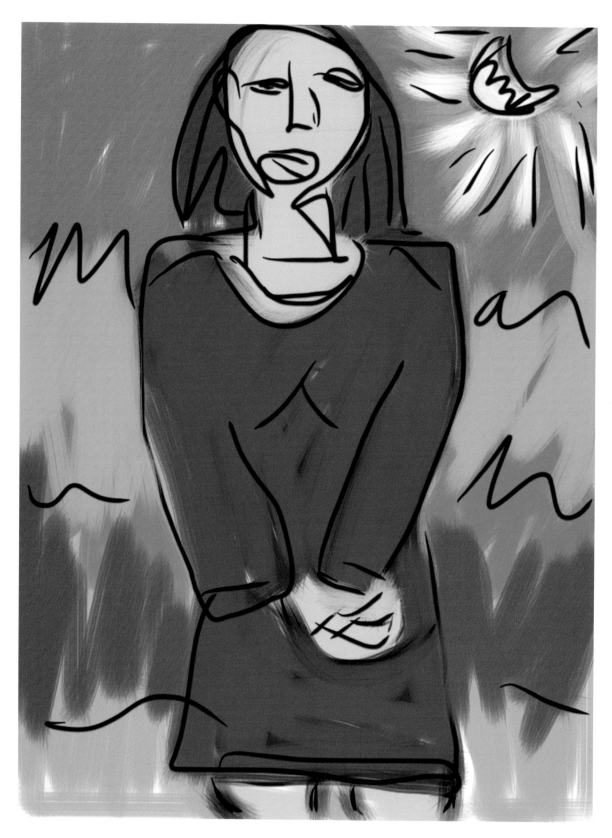

The only good thing about Marketing 101 was this girl Allison who sat next to me. She was pretty and sarcastic and as awkward as I was.

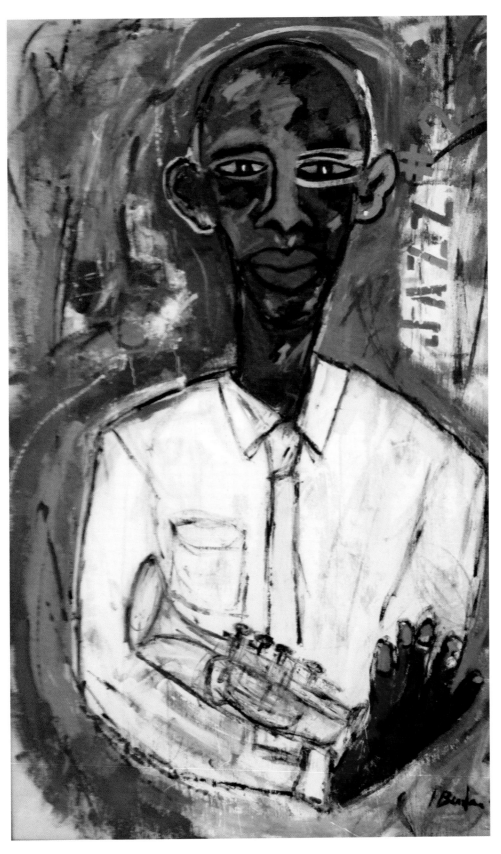

We dated and I took her to a local jazz club.
She got it. We got each other.

We fell in love and, after graduation, got married.

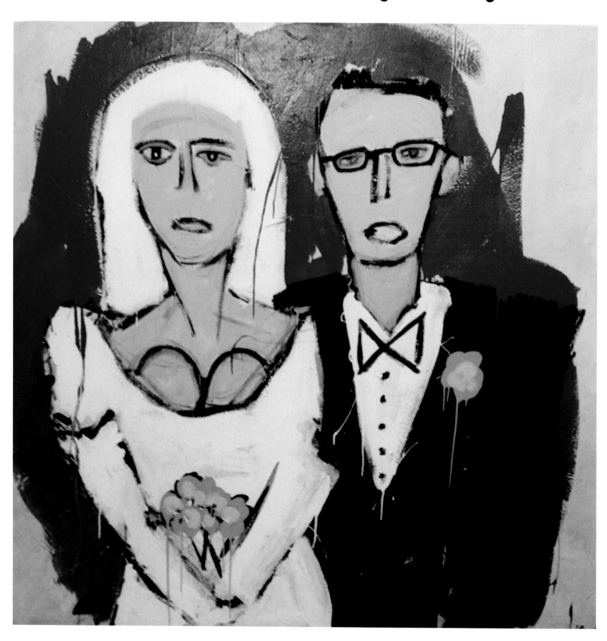

Dad suggested it was time I got serious and asked me to join his insurance company.

I knew better, but said, "Yes."

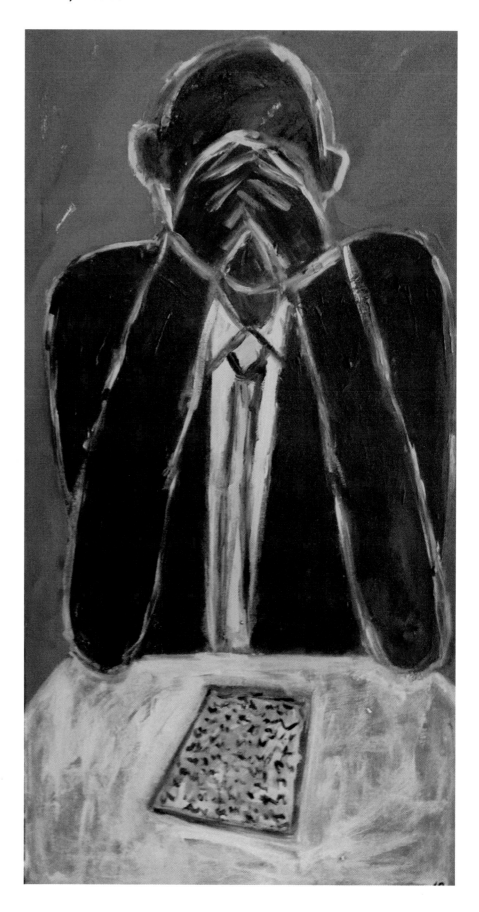

It wasn't long before I felt trapped in a
world I didn't belong.

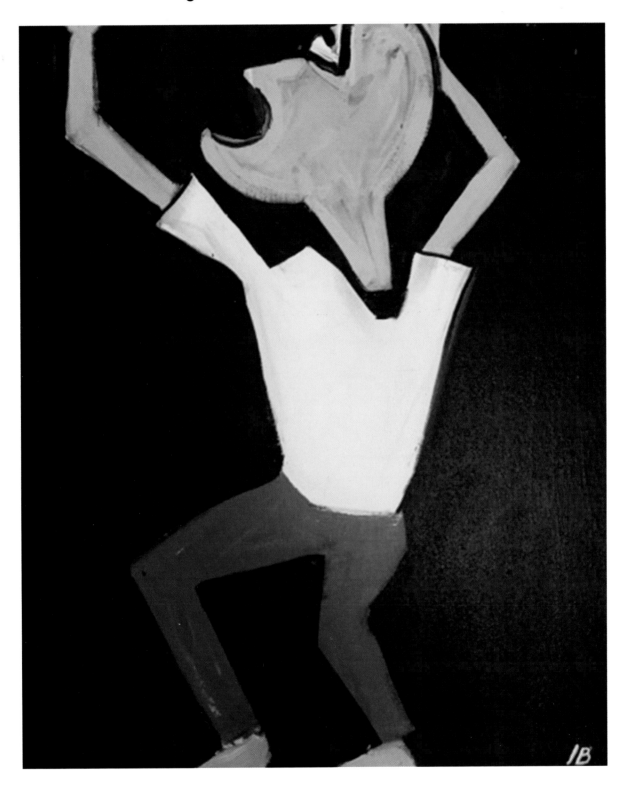

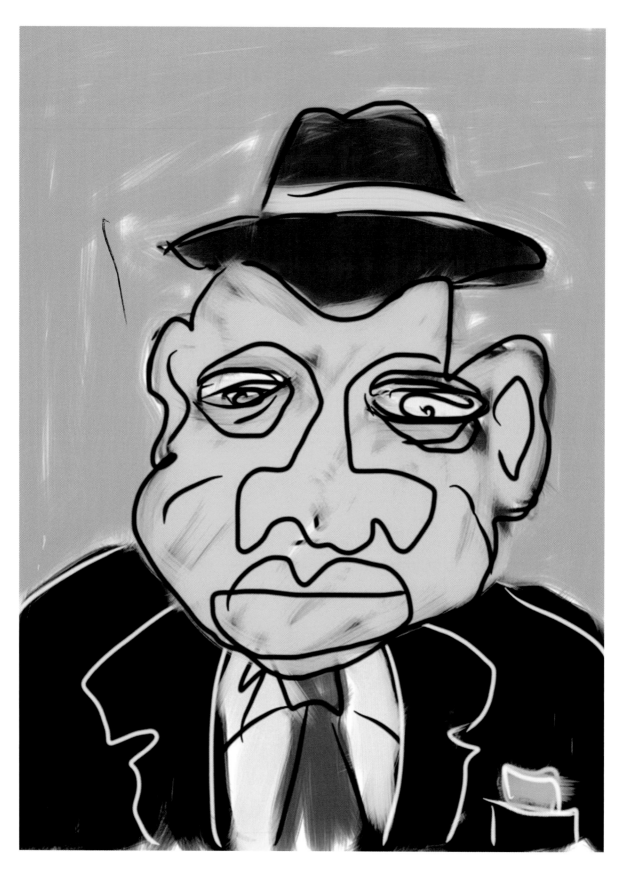

That's when Uncle Moe died
of a sudden heart attack.

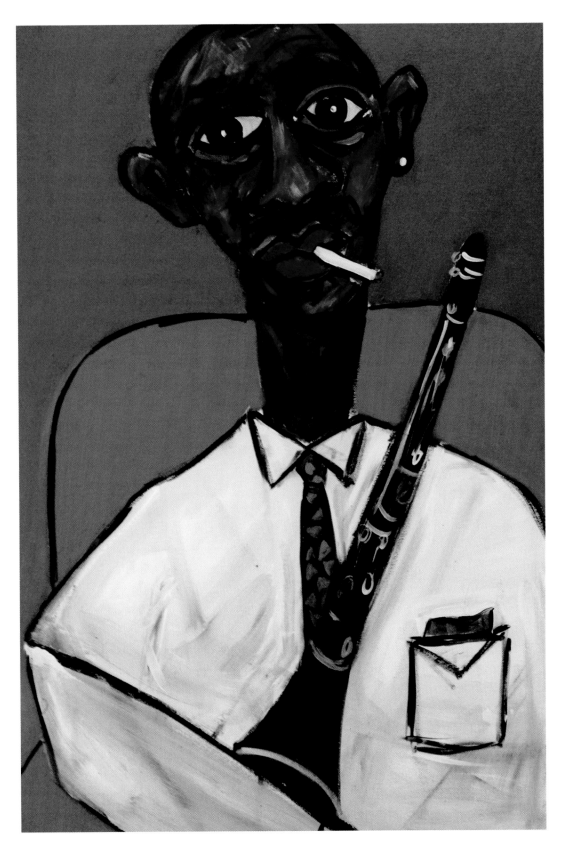

**The musicians came to me. They didn't want
the club to close and asked me to take it over.**

Allison and I took a long walk to discuss it.

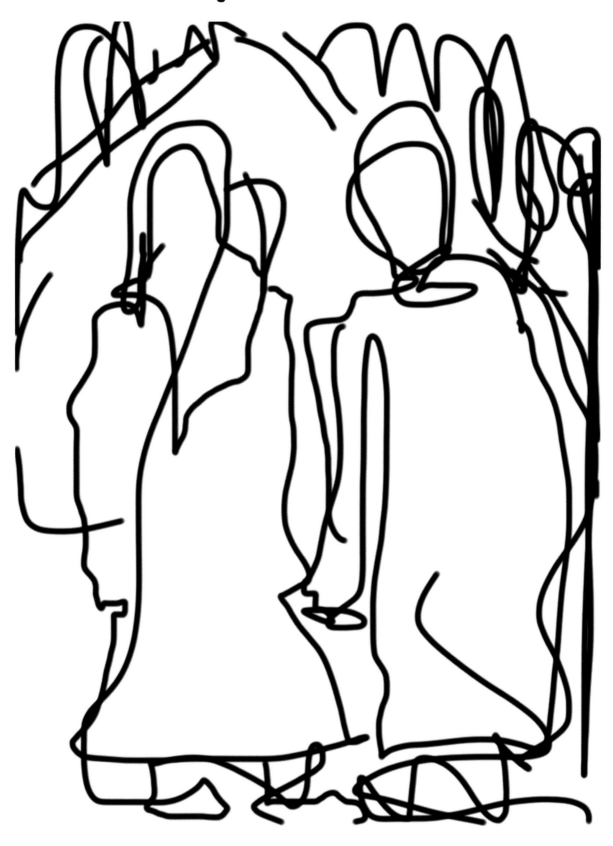

That's when my bold beautiful wife turned to me and said, "You have to do it. It's who you are!"

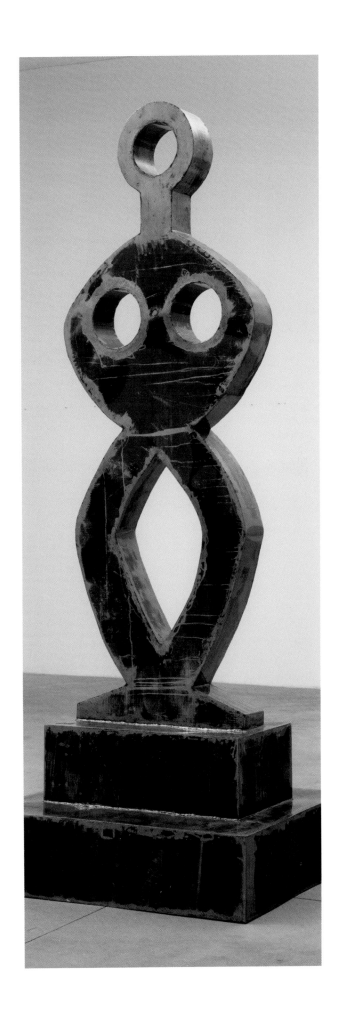

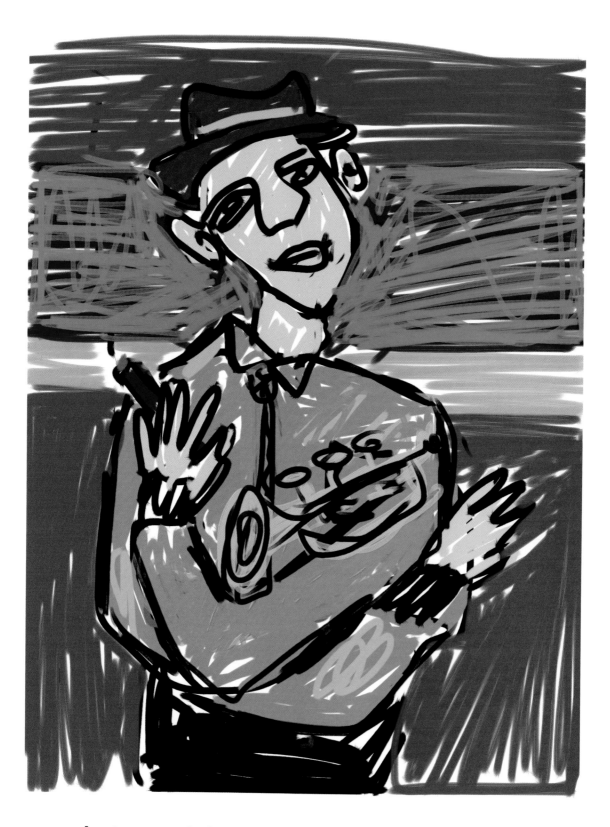

Against my father's practical protests and some of my own fears, I did it. I took the leap and bought the club. And, like the missing puzzle piece you couldn't find, I suddenly fit.

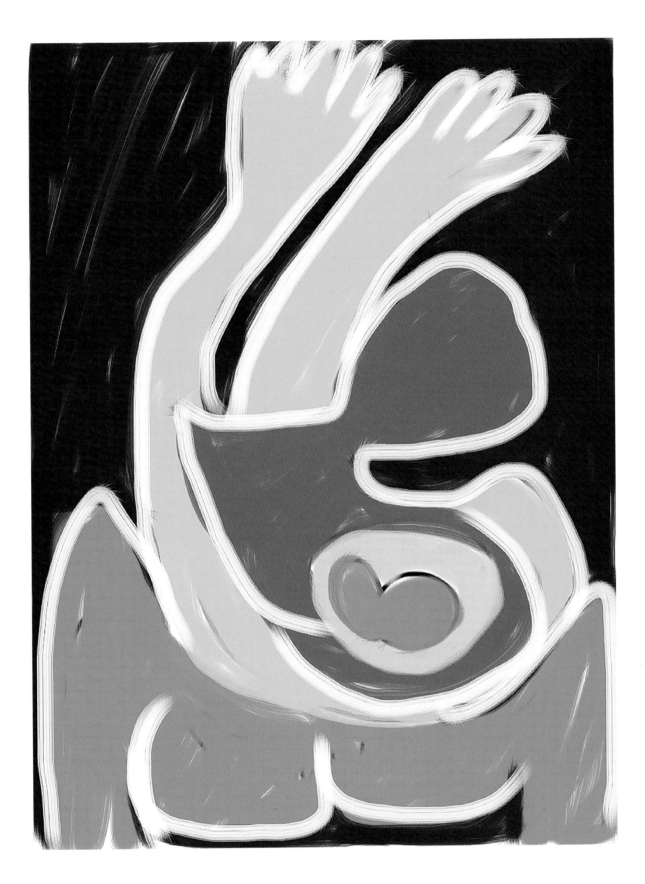

Shortly after, Allison got pregnant.

Nine months later, our baby girl was born.
We named her Moe-nique.

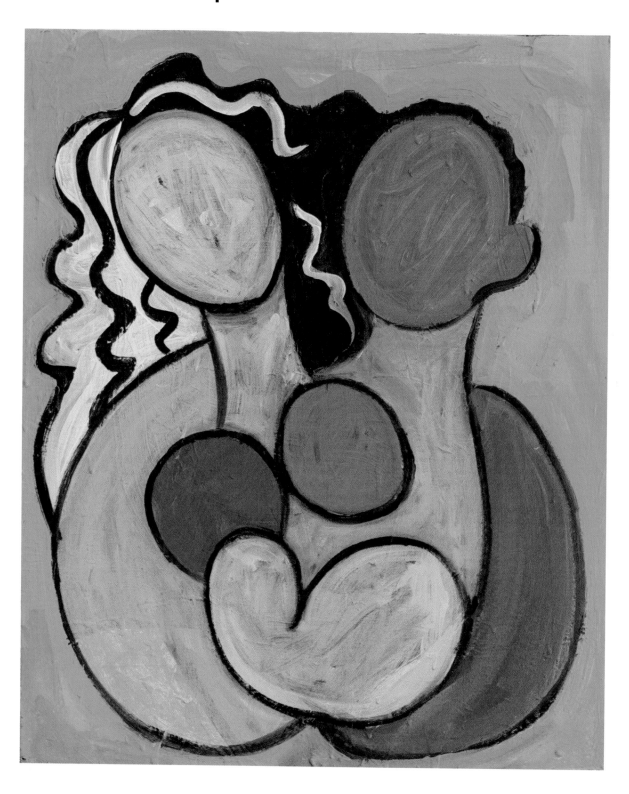

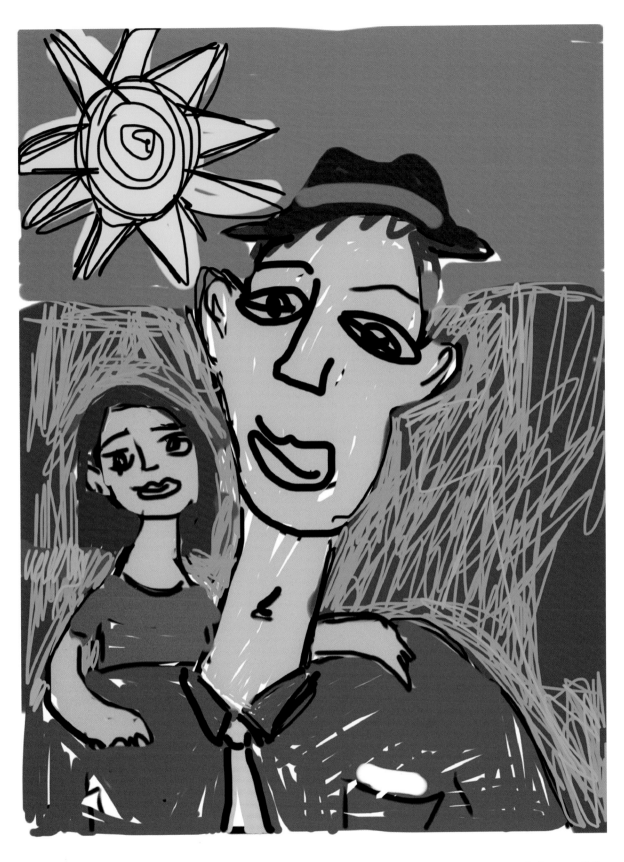

I knew she'd forgotten everything. I hoped I would
be a good father and help Moe-nique remember.

ACKNOWLEDGMENTS

Thanks to Howard Sanders at UTA for believing in this book from the beginning. Special thanks to all of my new friends at Inkshares and Girl Friday, including Adam, Matt, Meghan, Paul, Scott, and Emily, not only for their vision, but for their patience and guidance in bringing this book to life. Thanks also to Kendl, Martin, Eliana, and the entire team at Creative Matters. Special gratitude to Rabbi Mark Borovitz and Harriet Rossetto for their inspiration and honesty. I'd also like to send thanks to all the people I know, and those I don't, who have responded to my art over the years. For better or for worse (depending on your taste), I am incapable of stopping. It's the ride I am on.

—J.B.

The Elephant in the Room was made possible in part because of the following grand patrons who preordered the book on inkshares.com. Thank you.

Adam Gomolin
Adam K. Sabodish
Amy and John Peer
Barbara and Peter Benedek
Bill Smitrovich
Bob Myman
Brian K. Vaughan
Byrdie L. Pompan
C. Caroline Kahn
Candy Schulman
Carlos Rosario
Carole Obley
Charles Ferraro
Christina Elmore
Chuck and Merryl Zegar
Damon L. Lindelof
David A. Eisenberg
Dr. Jon Marashi
Dr. Myles Zakheim
Dr. Robert Koblin

Edison Park
Elizabeth Woodman
Emma Mann-Meginniss
Gene Stein
Geoffrey Bernstein
Harriet Rossetto
Harvey Myman
Howard Sanders
Jason Belsky
Jay H. Solomont
Jeffrey Abrams
Jo Garfein
Joel Mandel
John Robin
Jonathan Freeman
Joshua Voytek
Judith L. Jacobs
Kari Skogland
Ken Fabrizio
Leslie Schuster

Linda Thau
Lisa Hall
Mace A. Neufeld
Marc Kolbe
Matt Kaye
Mia
Mr. P. Bradley
Olivia St. Martin
Paul Inman
Peter King
Rabbi Laura S. Owens
Rabbi Mark Borovitz
Rabbi Yocheved Mintz
Rachael Berkey
Rebelfilms
Rob Mandel
Sean Tereba
Sergio.Mdcb
Stephen F. McNutt
Wendy Philips and Scott Paulin

Photo by Jonathan Freeman

ABOUT THE ARTIST

JACK BENDER is a lifelong painter and all-around creative force who brings a unique vision to the canvas. He uses painting and sculpture as a storytelling medium where he explores the intersection of spirituality, pop culture, and contemporary life in ways that are intellectually provocative, emotional, and visually stimulating. His works are intensely personal and raw.

Jack grew up in Los Angeles climbing roofs in his neighborhood, going from house to house without ever having to touch the ground. To him it was a "Southern California Chagall dream." He began studying painting at the age of fourteen with famed painter Martin Lubner. After studying fine art, drama, and cinema at the University of Southern California, Bender directed regional theater, and then launched his career in television, becoming one of the most celebrated director-producers in TV.

Bender has directed numerous TV movies, and his episodic work includes *Felicity*, *Alias*, *Ally McBeal*, *Carnivàle*, and *The Sopranos*. As executive producer and director, he was one of the lead creative forces behind the worldwide hit show *Lost*. Many of his original artworks were used in the show, including the iconic *Hatch Painting*. Under his direction, *Lost* won Best Drama Series at the Fifty-Seventh Annual Emmy Awards and the Golden Globes.

Most recently, Bender executive produced and directed the CBS hit *Under the Dome*, based on Stephen King's novel—and once again his paintings appeared in the show. After finishing the second season of TNT's hit *The Last Ship* for Michael Bay, Jack directed two episodes of the phenomenon *Game of Thrones*. He is currently in development on a miniseries based on Stephen King's bestseller *Mr. Mercedes*.

Inkshares is a crowdfunded book publisher. We democratize publishing by having readers select the books we publish—we edit, design, print, distribute, and market any book that meets a preorder threshold. Interested in making a book idea come to life? Visit inkshares.com to find new projects or to start your own.